IMAGES
of America

ST. FRANCIS DAM
DISASTER

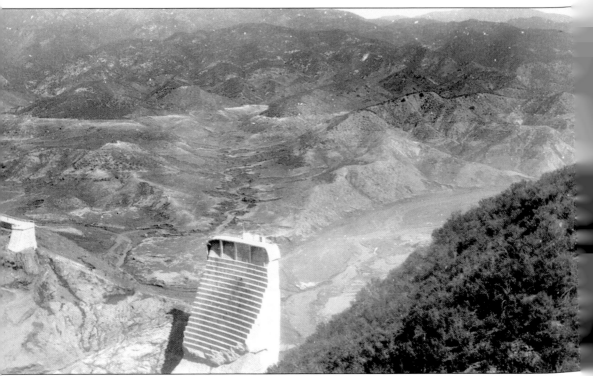

THE STANDING PIECE AND THE EMPTY RESERVOIR. St. Francis Dam was built by the Bureau of Water Works and Supply of the City of Los Angeles in 1925–26 as a curved concrete gravity dam in San Francisquito Canyon, about 5 miles northeast of what is now Santa Clarita, California. The purpose of the dam was to provide an additional 38,000 acre-feet of storage for Los Angeles-Owens River Aqueduct water close to Los Angeles.

The dam failed catastrophically upon its first filling, near midnight on March 12, 1928, killing at least 450 people. It was the greatest American civil engineering failure in the 20th century.

This book is dedicated to Leslie.

IMAGES
of America
ST. FRANCIS DAM
DISASTER

John Nichols

ARCADIA
PUBLISHING

Published by Arcadia Publishing
Charleston, South Carolina

Printed in the United States of America

Library of Congress Catalog Card Number: 2002110145

For all general information contact Arcadia Publishing at:
Telephone 843-853-2070
Fax 843-853-0044
E-mail sales@arcadiapublishing.com
For customer service and orders:
Toll-Free 1-888-313-2665

Visit us on the Internet at www.arcadiapublishing.com

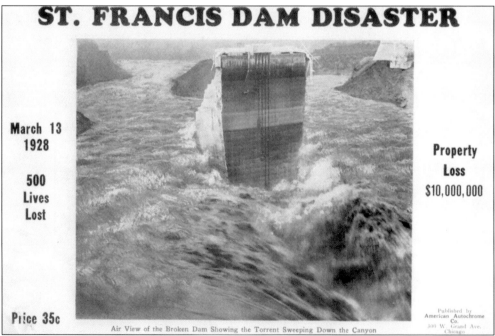

A BOOKLET PUBLISHED IN THE WAKE OF THE DISASTER. The cover illustration on this 35¢ booklet published by the American Autochrome Co. of Chicago shows a rather dramatic view of the floodwaters. The doctored photograph is suspicious for several reasons. No photographer could have been standing in this position during the dam break. The collapse occurred in the dark of night and could not have been photographed. The upstream side of the dam is facing the viewer and the rushing water is flowing in the wrong direction.

CONTENTS

ACKNOWLEDGMENTS

I wish to thank Mary Alice Orcutt Henderson and the Santa Paula Historical Society for the generous loan of images and research materials from their archives. I relied extensively on Santa Paula historian Charles Outland's *Man-Made Disaster: The Story of St. Francis Dam* and the recent geological and engineering revelations by J. David Rogers in the Ventura County Museum of History and Art publication *St. Francis Dam Disaster Revisited*. A special thanks goes to Megan Benner for assistance in assembling the images for this book, to Glen Goodrich for creative consultation, to Patty Fallini for the map, and to my first writing mentor, Peggy Kelly.

The photographs and postcards and the broadside shown in this book
are from my private collection except for the following:
The following 26 photographs are provided courtesy of the Santa Paula Historical Society:
2, 15, 22, 28b, 33, 37, 39a, 40b, 51, 58, 110, 111, 113b, 116b, 117,
119, 120b, 121b, 122a&b, 123a, 125a, 127a&b, 128a&b

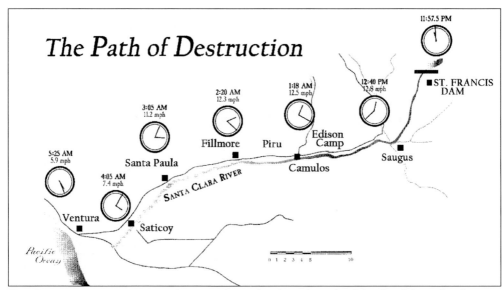

THE PATH OF DESTRUCTION. This map shows the 54-mile path of the flood from the dam site in Los Angeles County and down the Santa Clara River Valley through Ventura County to the Pacific Ocean. The clocks show the time that the flood reached each community. The speed is also indicated.

INTRODUCTION

Minutes before midnight on the chilly evening of March 12, 1928, the St. Francis Dam failed. The dam's 185-foot high concrete wall crumpled and collapsed, sending billions of gallons of raging flood waters down San Francisquito Canyon, about five miles northeast of Magic Mountain in what is now Santa Clarita. As the flood picked up debris it became a giant thick snake of mud and water and houses and bodies crawling at an average of 12 miles per hour down the Santa Clara River Valley and eating everything in its 54-mile path to the Pacific Ocean. It was a moving accident.

Built by the Los Angeles Bureau of Water Works and Supply, the St. Francis Dam Disaster was the greatest American civil engineering failure of the 20th century when it collapsed on its first filling. As a result of the dam's failure 1,200 homes were damaged, 909 were totally destroyed, 10 bridges were washed out, power was knocked out over a wide area, and the communities of Castaic, Piru, Fillmore, Bardsdale, Santa Paula, and Saticoy were paralyzed. An exact death toll is impossible to estimate because the bodies of many victims were washed out to sea with the floodwaters, but more than 450 people perished that night. It is California's second largest disaster; only the San Francisco Earthquake and Fire of 1906 claimed more lives.

A frog slowly heated in a container of water will swim about until it dies. Dropped into a container of hot water, the frog will immediately jump out. Like this proverbial frog, we are unable to sense a disaster unless it comes upon us suddenly like a fire or a flood. A slowly-evolving event is usually too imperceptible for humans to recognize, like the gradual erosion of our liberties and our culture. A disaster attracts our attention because it represents a moment when we have to wake ourselves up and pay attention to our world. Suddenly there's no sleeping in this classroom. The very thought of a significant disaster sensitizes all our nerve endings and nudges us to wake to the relatively disaster-free reality swirling around us daily.

One very human response to any significant event in our modern lives is the acquisition of images memorializing the strong reaction we had to the event. In this modern world we tend to stalk our emotional stimuli and hunt them down with a camera. The results are an accumulation of historical visual debris. Piles of visual debris can be torn apart and organized into something that might have meaning for humans far removed from San Francisquito Canyon or flooding or even the ever-present closeness of personal mortality.

I have pored over pages of old newspapers and the crumbling black pages of old photo albums. I have read and collected all the books printed on the subject. I have examined with a powerful lens the photographs that have been given to me for research, looking for elusive details that only a snapshot could reveal. I have scanned images at high resolution and zoomed in on details hidden to the naked eye. I have recorded family histories and the sagas of the survivors still living. I have immersed myself in the St. Francis Dam Disaster, and all this visual and verbal information bobs around in my mind like the homes and trees caught up in the debris flow that ravaged my hometown of Santa Paula.

The study of disasters is not depressing, not morbid. The stories and images that come out of any disaster connect us with our fellow humans and with our own humanity. They connect us not only with life and death but with each of the basic human characteristics we all encounter in life.

The focus on this current book of photographs is on the aftermath of the flood downstream and the impact on the lives of everyday people who lived and worked in the rural valley below the dam. Histories of the disaster have been written that cover the building, engineering, geology and politics of the St. Francis Dam. My intention here is to show as many photographs of the downstream aftermath as possible and weave in the stories of the heroes and survivors.

I have been guided by the essential research of Santa Paula historian Charles Outland who wrote *Man-Made Disaster* (unfortunately out of print and rare) and by the technical expertise of J. David Rogers who contributed to the Ventura County Museum of History and Art's *The St. Francis Dam Disaster Revisited*.

There will never be a complete telling of the story of the St. Francis Dam Disaster. We gather the facts as we find them and those facts are distributed downstream in random patterns just like the pieces of the collapsed dam.

One

DAM BREAK

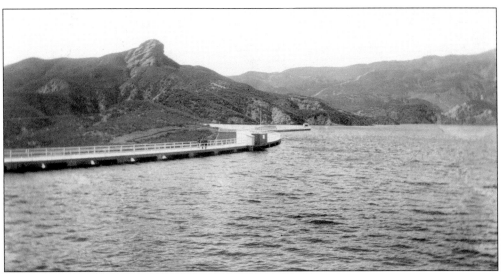

THE MORNING OF THE DAM BREAK. Pictured are William Mulholland, Chief Engineer of the Los Angeles Bureau of Water Works and Supply; Harvey Van Norman, Assistant Chief Engineer; and dam keeper Tony Harnischfeger walking across the crest of the recently filled dam around noon on March 12, 1928. That same morning Harnischfeger had telephoned Mulholland to tell him that a new, larger leak had developed on the west abutment of Sespe formation, and that the discharge was "dirty." This was cause for concern as this would be an alarm to the possibility of hydraulic piping. Mulholland chose to personally inspect the dam and arrived at 10:30 a.m. for a two-hour inspection. Mulholland and Van Norman left around 12:30 p.m. after assuring Harnischfeger of the dam's soundness.

Twelve hours later Tony Harnischfeger and his six-year-old son would become the first victims of the disaster. Their bodies were never found.

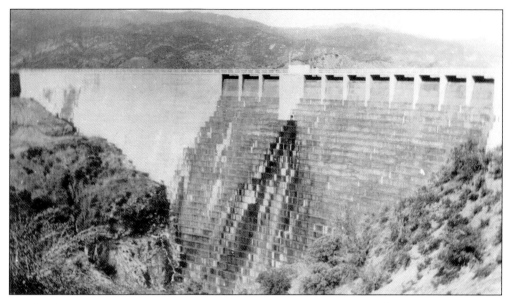

THE DOWNSTREAM FACE AROUND NOON ON MARCH 12. In "Man-Made Disaster," Charles Outland wrote: "Muddy water appearing in any leaks below the dam could mean only one thing—foundation material was being washed away from beneath the great structure. With the high pressure of a full reservoir it could only be a matter of time until a blowout occurred or the dam collapsed of its own immense weight."

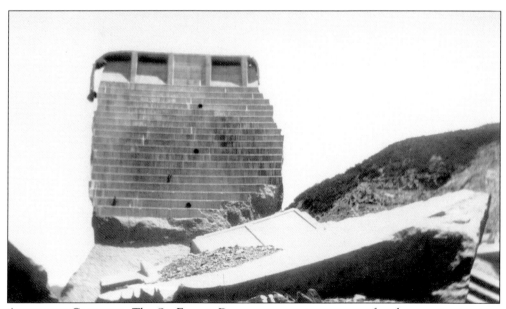

AFTER THE COLLAPSE. The St. Francis Dam was a massive concave-faced concrete structure 185 feet high that backed up an artificial lake 2.8 miles long. About 38,000 acre-feet of water was impounded behind the dam. The water weighed almost 52 million tons.

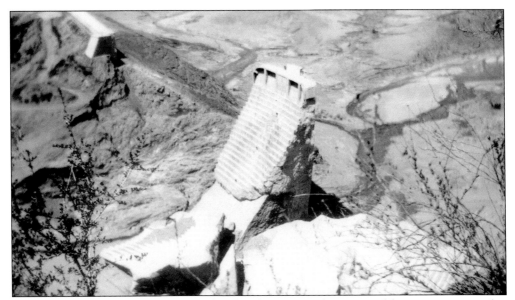

TONY HARNISCHFEGER WORRIED. The dam keeper openly expressed his concern a number of times on the dam's safety. He was so worried, his daughter later reported, that he had constructed a series of stairs to a high mountain behind his home to provide for the escape of his son and himself in the event of disaster. He was separated from his wife.

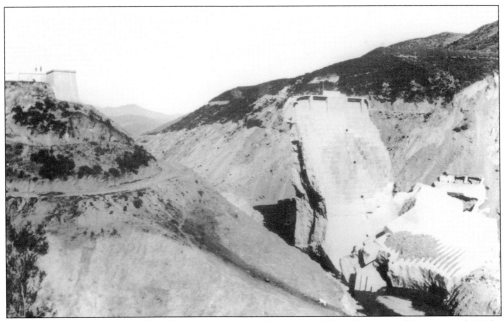

THE EAST ABUTMENT WAS BEGINNING TO COLLAPSE. Two Bureau of Power and Light employees told Charles Outland that they had driven along the dirt road alongside the dam a few hours before the collapse. They noticed that the road had "dropped at least 12 inches, just upstream of the east abutment."

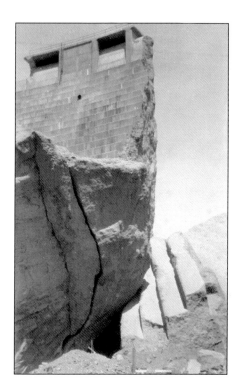

THE NIGHTMARE BEGINS. The lights of Los Angeles flickered momentarily at 11:57:30 p.m. on March 12 as the dam collapsed. The wall of water began its 54-mile trek to the sea at 18 miles per hour and by the time it reached Montalvo it was traveling at 6 miles per hour. In less than 70 minutes the reservoir was emptied of 12.4 billion gallons of water.

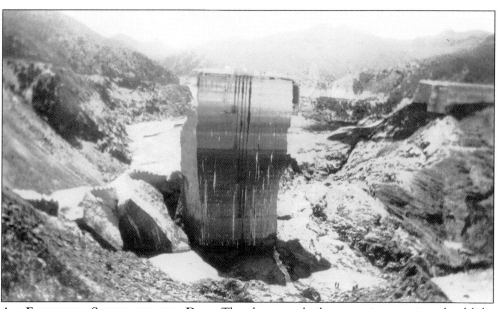

AN ENORMOUS STRESS ON THE DAM. The dam was built on a giant ancient landslide, which reactivated, with no evidence of seismic activity. The mass of land that moved weighed 877,500 tons, more than three times the weight of the dam itself, which weighed 250,000 tons.

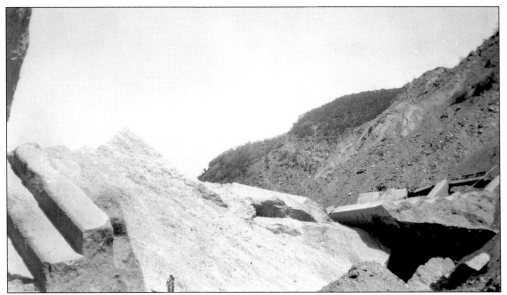

A ONE-YEAR SUPPLY OF WATER FOR L.A. The dam was built on a site chosen by William Mulholland, who presided over the creation of a water system that changed the course of southern California's history. His career began in 1886 and he retired in 1929. Mulholland was well accepted for his hydraulic engineering accomplishments but had little training in geology.

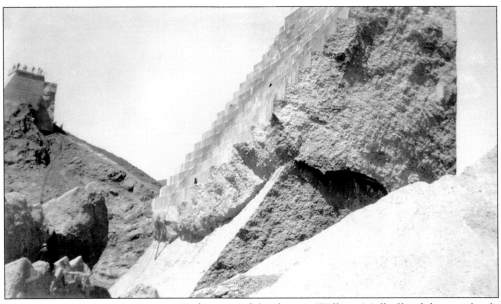

A GREAT MAN WAS CRUSHED. At the time of the disaster William Mulholland disconsolately accepted responsibility of the dam break with his statement, "Don't blame anybody else, you just fasten it on me. If there was an error of human judgment, I was that human." History has become much kinder to him than he was to himself. He died on July 22, 1935.

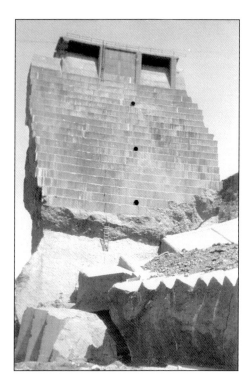

SCIENCE IS A CRUEL TEACHER. No one doubted the engineering capabilities of William Mulholland. His approval of a design and selection of a site were accepted without question by the Los Angeles Department of Water and Power. Many difficult lessons in geology and engineering were learned from this tragedy.

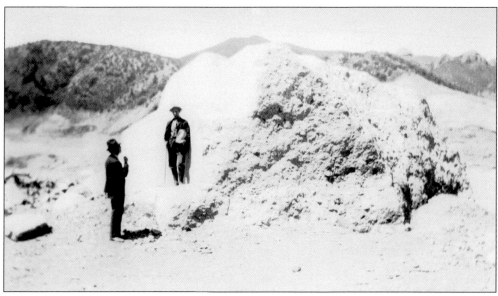

EVIDENCE WAS GATHERED. E.O. Goodenough, president of the Fillmore Chamber of Commerce, drove to the dam site two weeks after the collapse to examine the remains. He brought back two different kinds of rocks that formed the foundation. The rocks were so soft and crumbly that he would caution those who handled them to be careful lest they crumble them to pieces so he could no longer exhibit them.

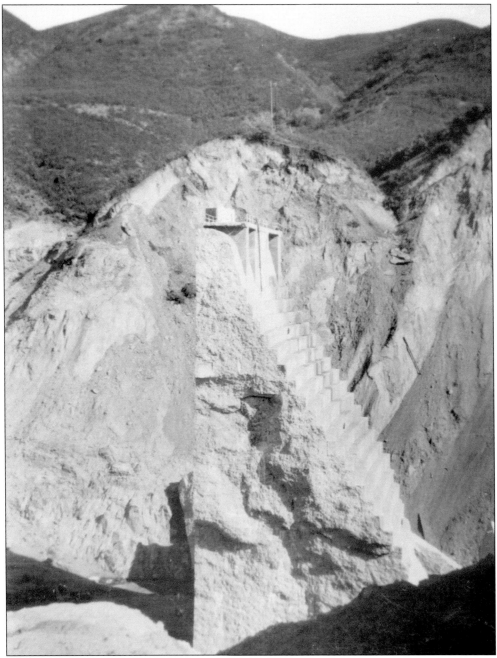

CROSS SECTION WITH A VIEW OF THE EASTERN ABUTMENT. In recent years detailed geological assessments have shown that the eastern or left abutment of the St. Francis Dam was unknowingly built upon a massive ancient landslide that reactivated, triggering the dam's failure. In discussing dams, the right and left sides are when facing downstream. The dam's failure sequence was likely brought about by a combination of factors, including excessive tilting when fully loaded, an absence of seepage relief in the dam's sloping abutments, as well as the partial reactivation of underlying Paleo mega-landslides within the Pelona Schist of the eastern abutment.

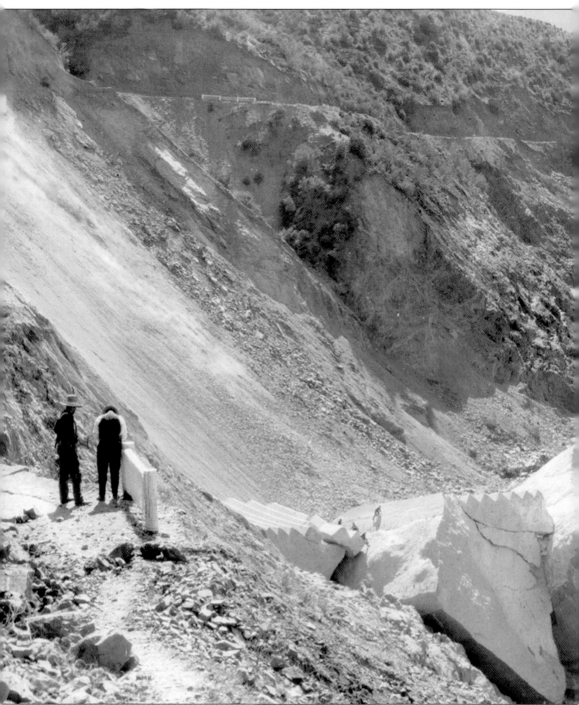

A Portion of a Panoramic Photograph. The dam measured 700 feet wide at the top and was 185 feet above the streambed. It was approximately 154 feet thick at the base, tapering to 16 feet at the crest. The standing monolith after the failure was 80–85 feet wide. The standing section had moved 5.5 inches downstream and tilted 6 inches toward the east abutment. In the vest and white shirt is Deputy Sheriff Carl Wallace, who accompanied photographer

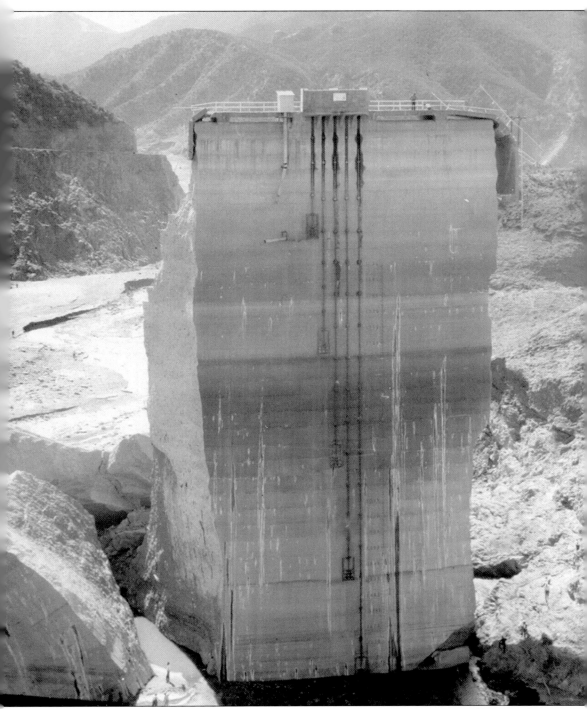

Bernie Isensee under orders from Ventura County District Attorney James Hollingsworth. They worked from the 15th to the 20th of March, 1928 taking panorama shots as well as many smaller views. A week later arrangements were completed between Los Angeles and Ventura Counties to settle damages and death claims out of court. With this action, Hollingsworth's precautionary gathering of photographic evidence became unnecessary.

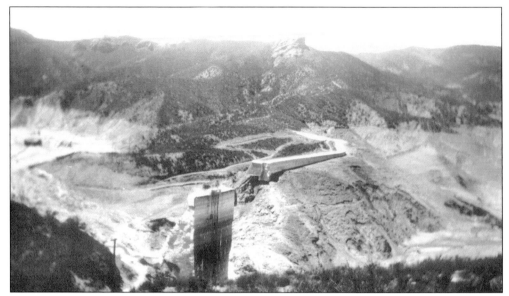

THE MIGHTY SURGE SCOURED THE CANYON WALLS. It gushed into the farmlands below, damaging over 1,200 houses, washing out 10 bridges, knocking out electricity and paralyzing Castaic, Piru, Fillmore, and Santa Paula with flooding. The losses were estimated at $13.5 million.

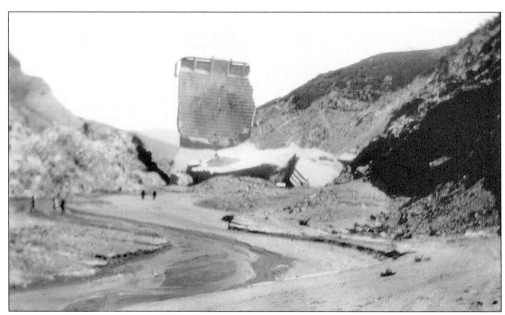

THE EFFECTS OF RELATIVE BUOYANCY. Five hundred thousand to one million cubic yards of weathered mica schist from the east abutment created a gigantic flow of moving mud with a much greater relative density than clean water. The submerged weight of the huge pieces of the dam was proportional to the density of the fluid displaced. This buoyancy effect resulted in enormous blocks weighing only a fifth of their dry weight.

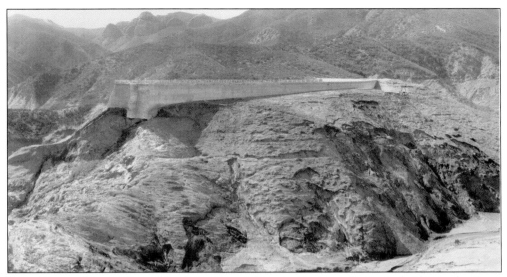

THE APRON STRING DIKE. The long wing wall across the top of a natural ridge in the Sespe formation beds is shown in this portion of one of Isensee's four-foot panoramas. It was added to the right side as a means of increasing the capacity of the reservoir. It was 588 feet long. The original reservoir capacity was to be 30,000 acre-feet of water. This was increased 39 percent by adding 10 feet and then later another 10 feet to the dam's height without increasing the dam's base width. This 11 percent increase in height necessitated the building of the wing dike. For a gravity dam that derives its stability from its weight this was a potentially dangerous action.

The home of Tony Harnischfeger, the dam keeper, was located just downstream of the dam. The wall of water that scoured this canyon was 135 feet high and its speed was 18 miles per hour.

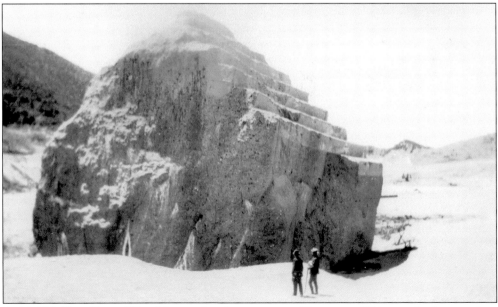

A 10,000 TON PIECE WAS MOVED AN ASTONISHING DISTANCE. This was the largest piece of the dam moved any appreciable distance downstream. This block came from the lower part of the west abutment. Blocks this size were moved by the slurry, which was dense and greatly diminished their effective weight.

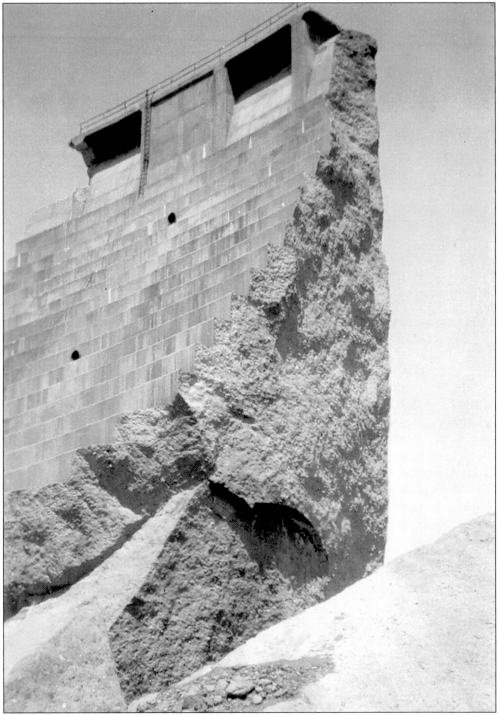

THE IMPORTANCE OF GEOLOGY. The dam's failure was the first experience that many Californians had with the importance of geology. The failure led to the development of a new branch of science, engineering geology (now commonly called environmental geology) and also led to key legislation to help protect the safety of the public.

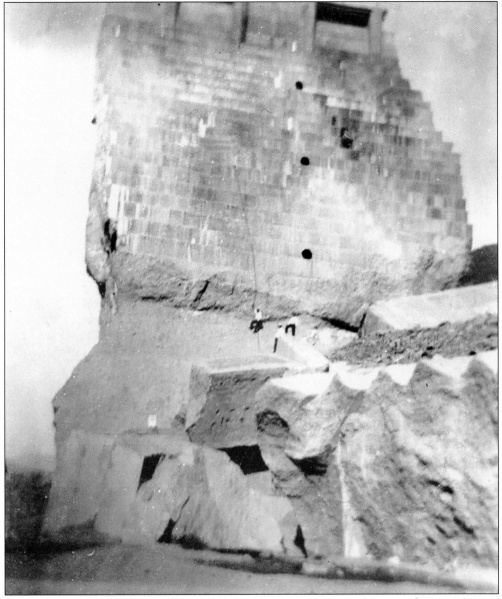

DEATH COMES FOR THE RISING FAMILY. Ray Rising, an employee of the Department of Water and Power, lost his wife and three daughters shortly after midnight on March 13. They were living in the family camp above Power House No. 2 where 25 people were swept to their death by the wall of water as high as a 10-story building. He was one of only three survivors there. He continued with the Department until he retired in 1963.

"We were all asleep in our wood-frame home in the small canyon just above the power house. I heard a roaring like a cyclone. The water was so high we couldn't get out the front door. The house disintegrated. In the darkness I became tangled in an oak tree, fought clear and swam to the surface. I was wrapped with electrical wires and held by the only power pole in the canyon. I grabbed the roof of another house, jumping off when it floated to the hillside. I was stripped of clothing but scrambled up the razorback of a hillside. There was no moon and it was overcast with an eerie fog—very cold."

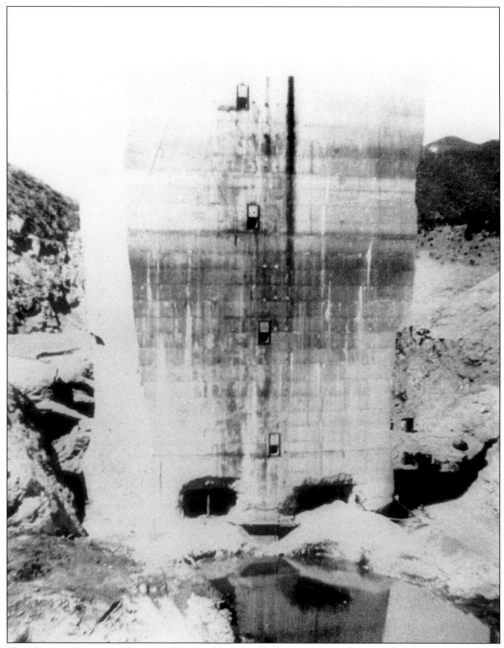

THE FINAL VICTIM. After an 18-year old man climbing the standing piece fell to his death in May 1929 (14 months after the failure) the City of Los Angeles chose to have the remaining pieces of the dam demolished.

Block 1 (as the standing piece is referred to by J. David Rogers in *The St. Francis Dam Disaster Revisited*) was blown backward by excavating its heel and loading it with explosives. What remains today is a low mass of concrete rubble next to the road that now runs through San Francisquito Canyon.

While it remained, the monolithic centerpiece of the failed St. Francis Dam stood as a grim reminder and a stark monument to death and disaster.

Two

HEROES OF THE FLOOD

THE WARNING COMES TO A SLEEPING VALLEY. Such men as Under Sheriff Howard Durley, Deputy Sheriff Carl Wallace, Deputies Ray Randsdell, P.J. Ayala, Charles Clements, and Ed Hearne were among the first men who gave warning up and down the sleeping valley. These men rode through silent citrus groves, among the unaware in swift cars and on powerful motorcycles, heading, ever heading, toward the terrible juggernaut that was breaking everything in its path.

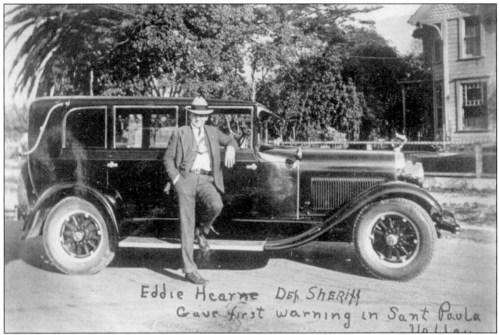

Eddie Hearne Dep Sheriff
Gave first warning in Sant Paula Valley

THE DEPUTY'S CADILLAC. Deputy Sheriff Eddie Hearne was on duty at the Ventura County jail when the warning from L.A. came at 1:20 a.m. He made a wild dash up the valley in his Cadillac squad car. His orders were to go as far as he could, warn as many as possible, and render aid where possible. Outside Fillmore his headlights met the devastating flood, forcing him to retreat.

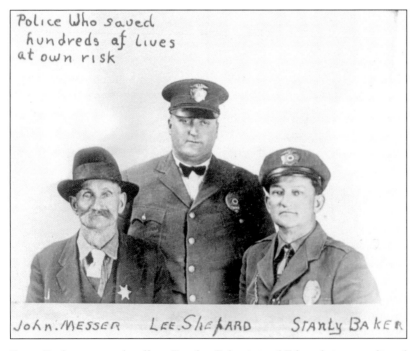

Police Who saved hundreds of lives at own risk

John. MESSER Lee. Shephard Stanly Baker

THE POLICE WHO SAVED HUNDREDS. Santa Paula Chief of Police Lee Sheppard was called at 2:05 a.m. Highway Patrolman Thornton Edwards and other officers received their calls at 1:30 a.m. or later from Louise Gipe, local telephone operator. Shortly before 2:00 a.m. Santa Paula motorcycle officer Stanley Baker joined Edwards in spreading the warning. Constable John Messer also helped spread the warning to sleeping citizens.

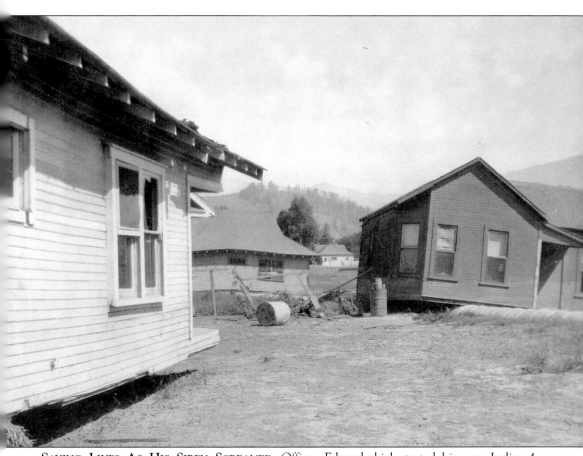

SAVING LIVES AS HIS SIREN SCREAMED. Officer Edwards kick-started his new Indian-4 motorcycle and headed for the low-lying part of town. There he made a life and timesaving decision. He went to every third house and told the occupants to warn their immediate neighbors. Then he went to the fifth house and repeated the process until he worked his way down a street.

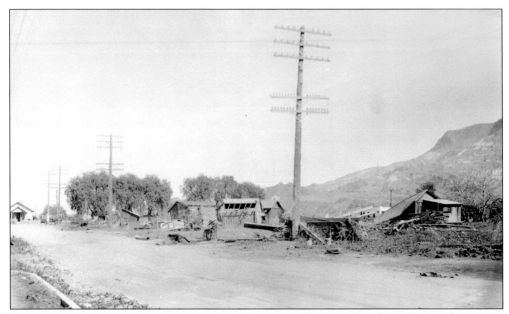

RACING TO SAVE LIVES. Thornton Edwards covered as much of the lowland territory on his motorcycle as he could before running out of time. As he turned onto Harvard Boulevard at Steckel Drive he was going too fast to stop as the floodwaters appeared directly ahead of him. Edwards recalled that his only thought at that time was the likely loss of his new $500 motorcycle.

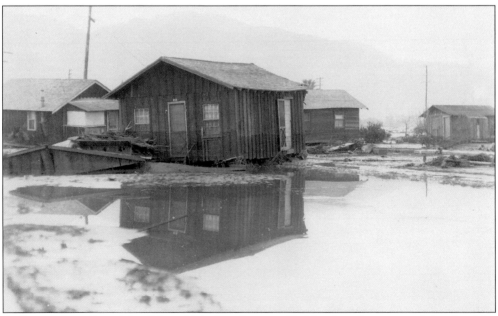

A CHANGE OF OIL. After Edwards' Indian-4 was stalled by that first wave of the flood he hitched a tow into town where he drained the oil and water from his motorcycle's crankcase and refilled it with fresh oil. The motorcycle started and he quickly set off to join his wife and son. For his actions, Thornton Edwards became the first Highway Patrol officer ever honored for bravery.

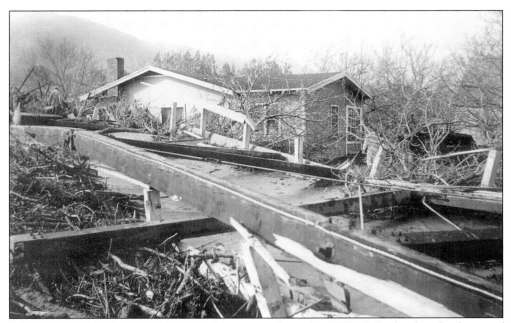

WHILE HE WAS SAVING LIVES. A long piece from the Willard Bridge hit the home of Thornton Edwards, swinging it two or three hundred feet off its original foundation. House and furnishings were a total loss.

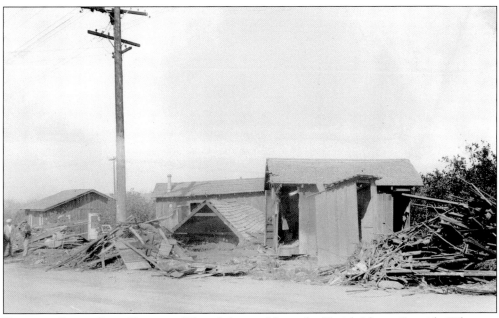

EDWARDS SPOKE ONLY ENGLISH. Edwards later told people, "I wish I knew Spanish. When we aroused those Mexicans down by the river, all I could say was, *mucha agua*, and point east. Many of them laughed and looking up at the sky said, *No esta lloviendo* (It isn't raining.)"

HEAD FOR THE HILLS. Motorcycle officer Stanley Baker soon joined Edwards and the pair moved swiftly but methodically through the streets at most risk. The auxiliary fire station whistle wailed to call two dozen volunteer firemen who dispersed and directed people toward the hills.

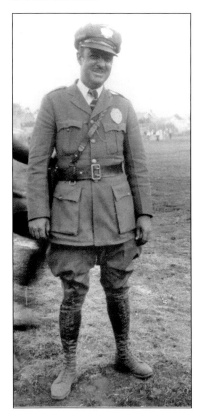

HOLLYWOOD CALLED. After being police chief of Santa Paula from 1929 to 1939 Edwards moved to Santa Monica and for three years he appeared in films, many of them westerns. Among the films he appeared in were *Grapes of Wrath*, where he played a police officer, and *Topper*, in which he appeared as a motorcycle cop who tried to stop the speeding auto driven by the invisible driver.

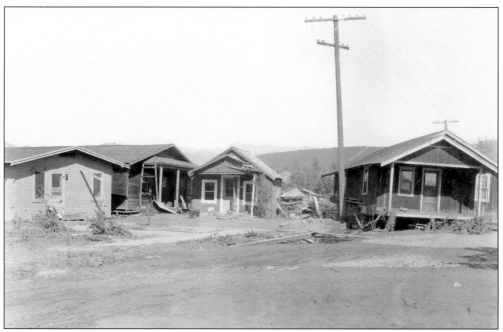

THE HEROIC HELLO GIRLS. Night operator Louise Gipe got word of the flood from a long-distance supervisor shortly before 1:30 a.m. She first called Thornton Edwards and city officials and then the other operators. The "Hello Girls" began immediately calling residents along the river lowlands. These brave women stayed at their post knowing only that the wall of water was over 100 feet high when it left the dam.

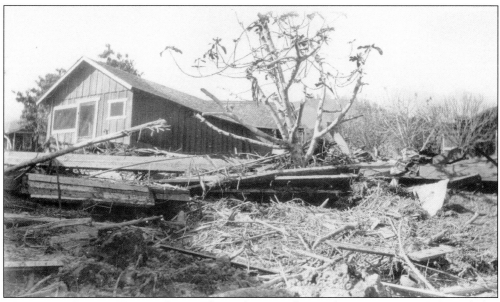

WARNING CALLS WENT OUT. The other "Hello Girls" were Mrs. B.O. Clarke, Mrs. Margaret Osborne, Thelma Neugebauer, Genevieve Burns, Lela Cochran, Exie Voris, and Florence Barlowe. They had no way of knowing how high the floodwaters would be by the time it reached Santa Paula. They only knew that their neighbors must be warned.

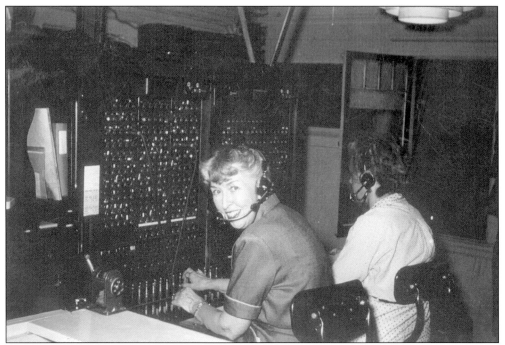

THEY WORKED WHILE OTHERS FLED. In Saticoy the operators who stuck by their posts were Reicel Jones, left, and Althea Marks, shown here in a 1955 photograph. Only one thing traveled faster than the floodwaters and that was their emergency calls. When it was all over each was given a $25 check of appreciation. Small exchange for the dozens of lives they saved.

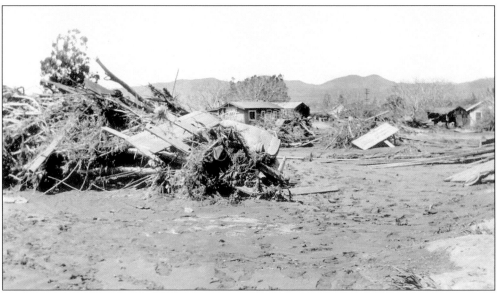

SAM PRIMMER ALSO RODE. All was confusion in Santa Paula as whistles blew, sirens screamed, and horns honked. Fire Chief Sam Primmer rode madly around town on his motorcycle calling to sleeping residents to abandon their homes and head for higher ground. Many heard and yawned, looked at the cloudless sky, thought it was a prank and went back to sleep. They did not live to regret it.

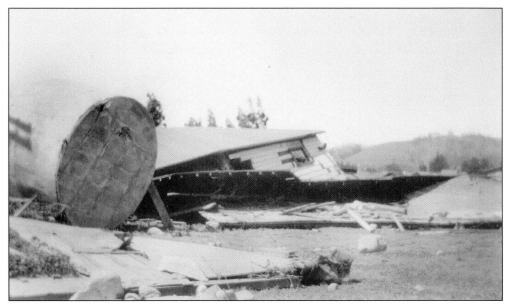

A YOUNG HAM HELPED OUT. Sam Primmer's 17-year-old son, Charles, broadcast all day on his ham radio set, to lighten the telephone switchboard load. Lou Baumgartner of the American Red Cross broadcast his appeals for help over young Primmer's set.

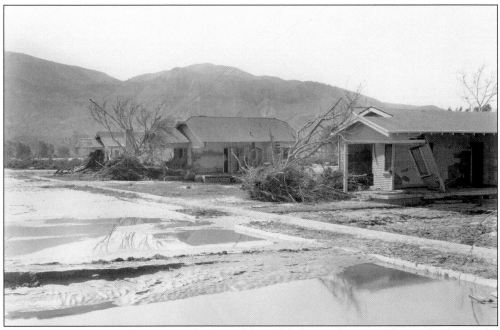

THE WARNINGS ARE SPREAD. "I had an old Studebaker with a steamboat whistle on the muffler and I rode around waking everyone up," recalled Harold Newman. He and his wife suddenly caught sight of the flood in their headlights. "So I drove backwards until we got to where the water couldn't reach us. My wife said she never drove backwards so fast in her life."

31

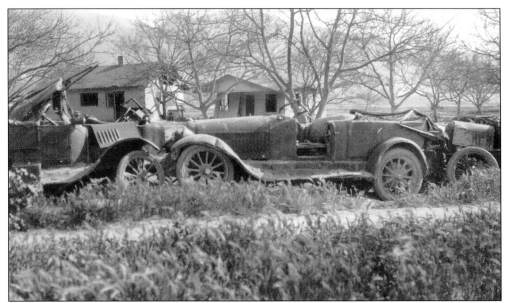

THE WARNINGS PROVE TRUE. Carl Dickinson, Santa Paula stationmaster, was dragged out of his bed with word that the aqueduct had been dynamited and the whole town would be washed away. He asked a man if there was any truth to the flood alarm. The man said, "Well, I guess there is. I went to helping my pardner and I lost my car. It got away in the flood."

THE BUSY DEPOT. At 4 a.m. Dickinson's first telegram was for a young Mexican man who told him he had lost seven from his family. Dickinson worked straight through until 11 p.m. when he had to lock up so he could sleep. He returned at 5 a.m. the next morning and worked again until nearly 11 p.m. as telegrams came in from all over the country.

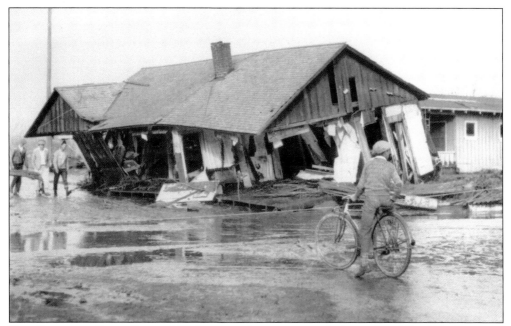

THE RESCUERS SAVED LIVES. "We have just begun to scratch the surface," Ray Weigle, one of the officials in charge of the work stated. "All we hope at the present is to save lives that have not yet been snuffed out despite hours of the most awful deprivation imaginable to mankind."

While rescue crews worked, many residents took time to view the wreckage of their city amid pools of floodwater still standing in the streets.

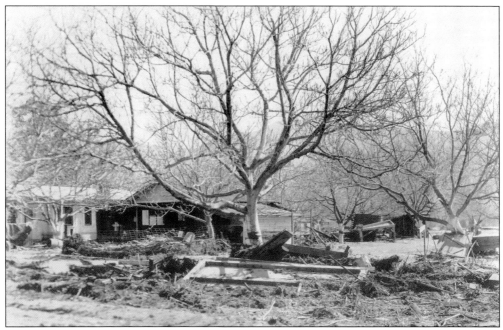

A GIRL IS RESCUED IN A TREE. "She had lost her nightgown and had no clothes on when we found her, and she was so embarrassed that to this day she pretends she doesn't recognize me," recounted a man who rescued a 12-year-old girl from a tree.

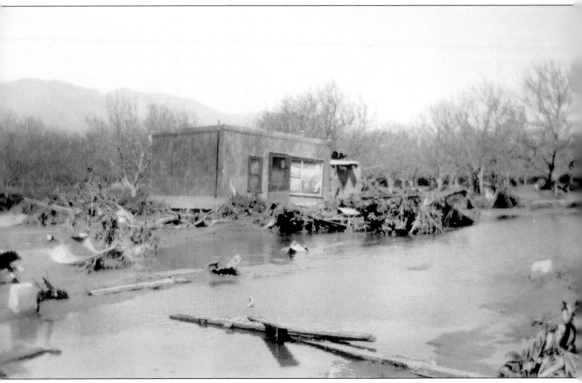

THE RESCUE OF SOLEDAD. Nick Baxter, a Legionnaire from Santa Paula and a disabled veteran of World War I, made the first rescue in Santa Paula before daybreak when he plunged into the chilly water at Harvard and Barkla Streets and rescued Soledad Luna, an 11-year-old Mexican girl who was lodged in a walnut tree. His record for that first day of the disaster was three lives and three bodies.

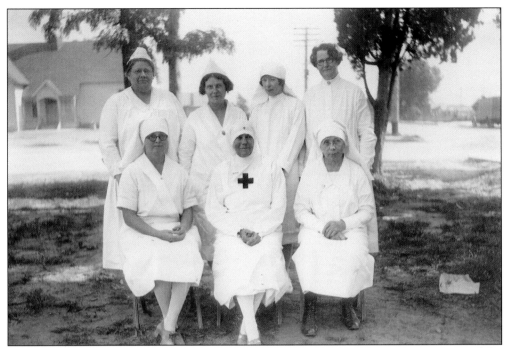

THE RED CROSS SERVED WELL. The "customary tireless efforts" of the Red Cross inspired the best efforts from an affected population.

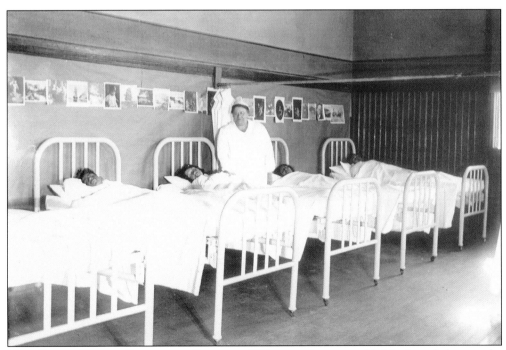

THE *SANTA PAULA CHRONICLE* REPORTS. "Discovered a year-old Mexican baby on the Roger Edwards ranch. The baby was taken first to the undertaking parlors because it was believed to be dead. But it is now crying lustily at the day nursery."

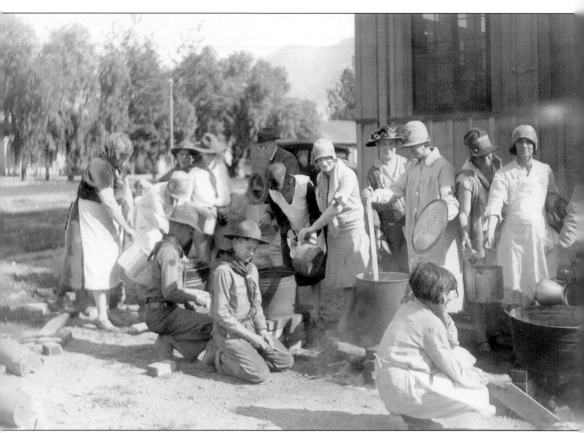

SCOUTS RUB TWO STICKS TOGETHER. The people of the community rallied together to provide aid and comfort to the afflicted. The old South Grammar School was one of the busiest spots in Santa Paula. Meals were served on the campus and kind matrons within the school dispensed first aid to suffering refugees. As always the Boy Scouts were prepared.

Three

GRIM DEATH AT EDISON CAMP

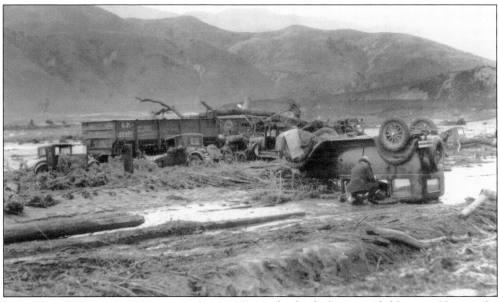

TRAGEDY STRIKES A WORKERS' CAMP. Grim death dealt a cruel blow at Kemp, the construction camp of the Southern California Edison Company about four miles east of Piru, when the mountain of water hit without warning at 1:20 a.m. About 40 feet above the river, 150 men were asleep in their tents on a small meadow. Eighty-four men perished. A 60-foot wall of water crossed the Ventura County line at the little railroad siding of Kemp and swept over the sleeping workers.

The workers were stringing a power line from Saticoy to Saugus. They were camped just above Blue Cut, a few miles west of the Los Angeles/Ventura county line. How many died there was never exactly known. There was no Social Security or unemployment withholding tax in those days and personnel record keeping was not the exact science that it is today.

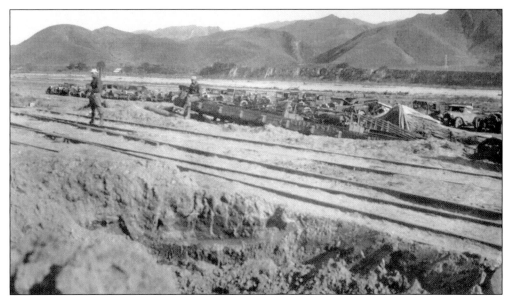

THE WARNING WAS DROWNED OUT. Edison security officer Ed Locke thought for sure the phone was ringing, but when he got to the phone the line was dead. That night the warning call never got through. His body was later found wearing a heavy topcoat that he had not had time to take off while warning the men. Swimming would have been impossible.

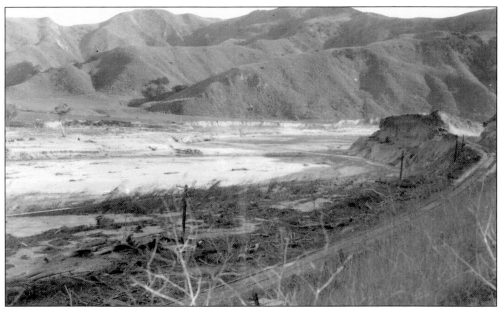

THE WHIRLPOOL EFFECT. Mountains surrounded the campsite to the west and a spur of hills jutted out at a right angle to the river, forming a partial natural dam. The flood wave struck Blue Cut and rebounded to the east, creating a huge whirlpool. Water swirled from the south and bounced back from the west, causing some of the men to think they were the victims of a tidal wave.

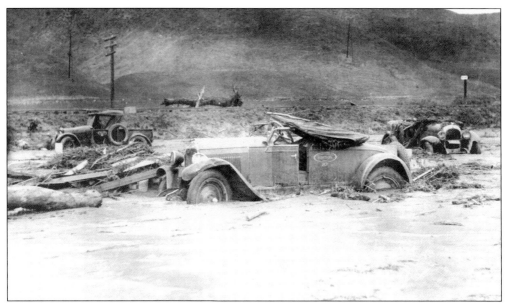

CANVAS BECAME A DEATH SHROUD. Those Edison workers who enjoyed fresh air and slept with their tent flaps open found their tents quickly filled with water and the heavy canvas became their death shroud. Bodies were later found with fingernails ripped off in the futile attempt to claw to freedom. Sealed flaps created floating tents and gave these men at least a slim chance to survive.

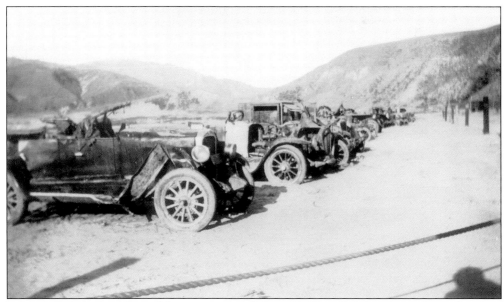

A MIND DISTURBED. One of the survivors made it to the shore but the experience so disturbed his mind that he fled naked into the hills and two days later was still avoiding aid and comfort from rescue parties.

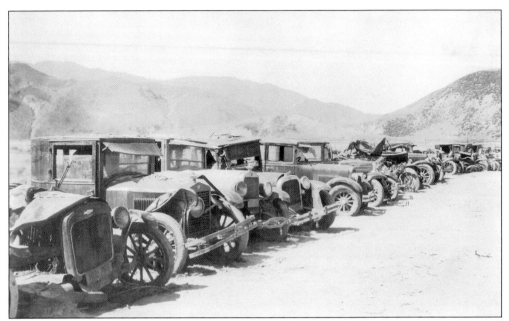

RUSSEL ROTH'S TENT. "I was on top of a raft composed of part of the tent and was being tossed around. Finally I got aboard a big metal object, which proved to be the water tank, and this saved my life. I rode this until I was dashed up onto the shore. Then I ran up the hill and some fellow ran by me and I haven't seen him since."

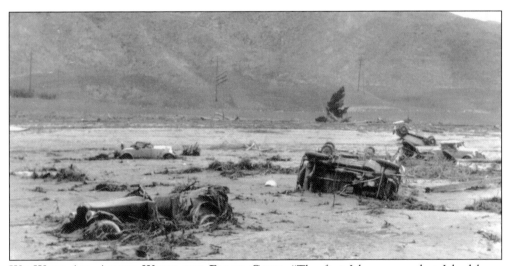

WE WERE ALL ASLEEP WHEN THE FLOOD CAME. "The first I knew was that I had been thrown against the roof of the tent in which I was sleeping," said Oliver Crocket. "The water had come underneath the tent and we were imprisoned there for an hour before we reached safety. All around me tents were swirling and men were being thrown about like straws. I never saw them again."

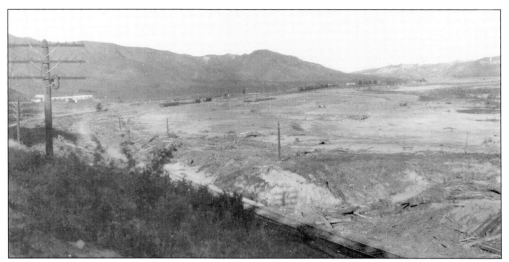

"I SAW A LIGHT ON THE SHORE." One survivor floated around and around in the dark and deadly whirlpool at Blue Cut and each time he circled he saw a light on the shore. He couldn't convince his tent mate to try for the shore. He eventually swam toward the light but never saw his buddy again.

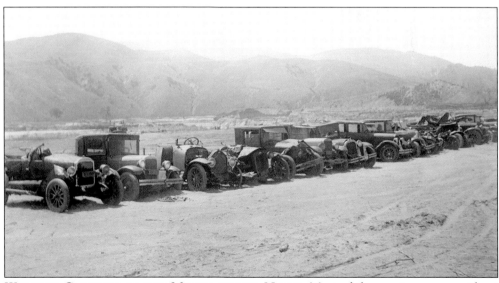

WITHOUT CLOTHING IN THE MIDDLE OF THE NIGHT. Most of the survivors were without clothing but found food and clothing at the ranch of Steve Bourgonio in the hills at the county line. Bourgonio had the only automobile left in the area and was able to move the injured Edison employees to a point within a mile or so of waiting cars at the J.M. Sharp ranch, "Isola."

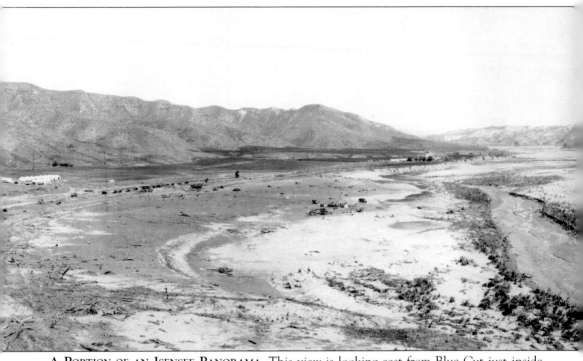

A PORTION OF AN ISENSEE PANORAMA. This view is looking east from Blue Cut just inside the Ventura County line. This portion of an Isensee panorama shows cars assembled at the site of the ill-fated Edison construction camp. The tents at the left were erected after the flood for rescue and salvage crews. At this point the floodwaters were traveling at 12.5 miles per hour.

Four

EVERYTHING IN
ITS PATH

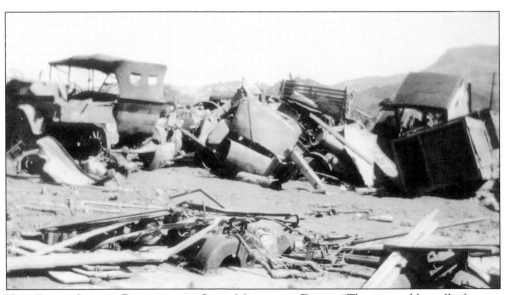

THE FLOOD SEEMED POSSESSED BY SOME MALICIOUS DEVIL. "The invincible wall of water, possessed it seemed of some malicious devil, struck without warning in the dark of night, trapping scores of families asleep and without means or hope of escape." A melodramatic portion of an official Los Angeles report dated July 15, 1929, on 348 death claim settlements in the wake of the disaster.

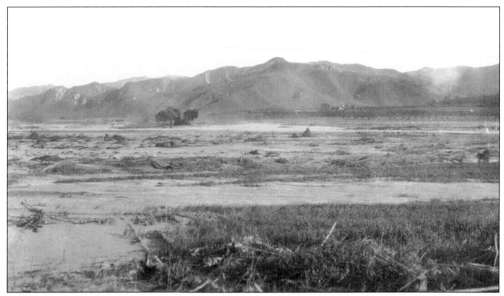

DEAD BODIES WERE GATHERED AT NEWHALL. Bodies found in the wreckage and debris were laid out on 1 foot by 12 foot pine plank slabs and crowded into the temporary morgue in the Masonic Hall, each slab with its body.

THE WALL OF WATER. That wall of water surged by with the roar of a thousand locomotives, sweeping everything before it.

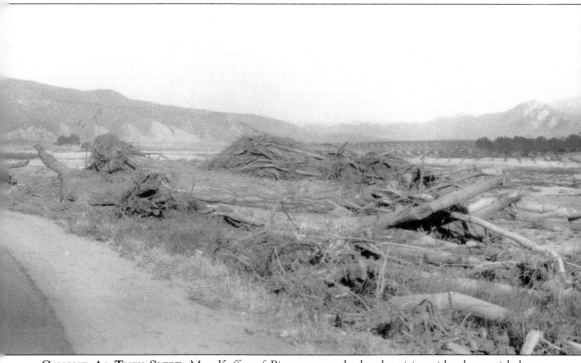

CAUGHT AS THEY SLEPT. Mrs. Koffer of Piru was caught by the rising tide along with her husband and son as they slept in their beds. They floated downstream on the raging waters. The bed carrying her husband and son was separated from hers by only a short distance as they both floated downstream. She was drowned when her ship bed tipped over after hitting a stump. Her husband and son survived.

THREE HEROIC DOGS AT CASTAIC. Thirteen-year-old Peggy Wilmont was sleeping in her bed near Castaic Junction. She covered her head with a pillow when she heard the water, thinking it was thunder. When it hit, her bed flew across the room as the house disintegrated and the roof collapsed on her and her family. "I don't know how I got out but when I regained consciousness I was sitting on debris in the floodwaters. Burning telegraph poles afforded enough light and as the wires shorted out I could see the outline of the hills."

She tried to climb to safety but was turned back repeatedly by the family's three dogs. Later, she learned that the dogs prevented her from walking into a 20-foot deep washout. Finally she reunited with her father on the shore. It was then that she learned fallen high power lines had electrocuted her mother and sister. Her brother's body was found three days later in Piru, caught in debris.

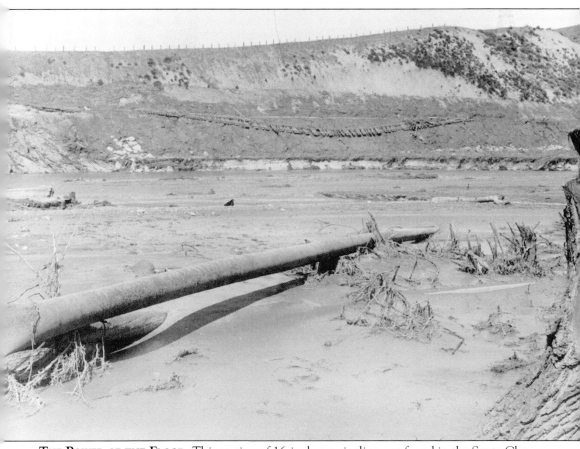

THE POWER OF THE FLOOD. This section of 16-inch gas pipeline was found in the Santa Clara riverbed. The raging water bent the pipe double. Along the flood-carved cliff at the rear can be seen a section of railroad track uprooted and displaced by the flood.

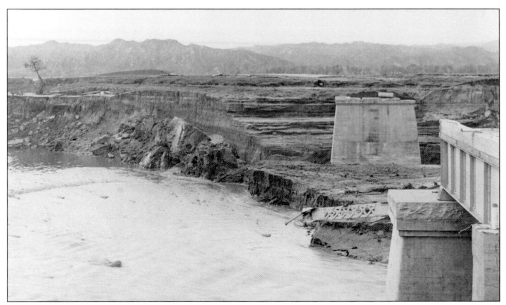

THE SANTA CLARA RIVER BRIDGE SOUTH OF CASTAIC JUNCTION. This view is looking toward Santa Paula. Washed away was 240 feet of the bridge. Girders from this structure were carried 8,000 feet down stream. A major gas supply line was ripped out from its position under the bridge.

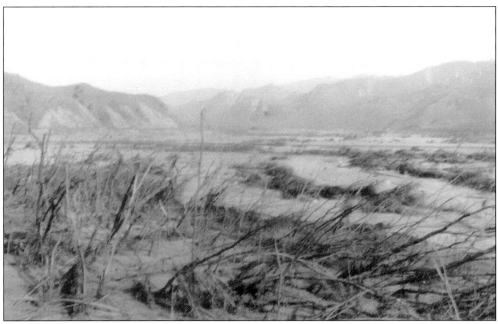

THE DAMAGE WAS NOT ALL PHYSICAL. "Crazed, evidently by the loss of his family, an unidentified Mexican man today escaped from rescue crews who attempted to capture him near Piru by running down swamped orchard lanes. He was scantily dressed and screamed as he ran." *Santa Paula Chronicle.*

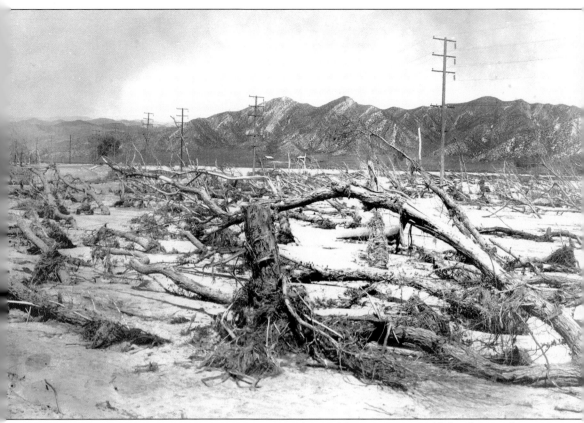

A YELLOW CUR WARNS A PIRU FAMILY. A mother and her seven-year-old daughter and six-year-old son were at home at their adobe ranch house four miles south of Piru. The family dog, a yellow cur, sounded the warning when the floodwaters hit. Giant pine trees surrounded the adobe house and these held back the debris in the muddy water. The father was away for the night in Reseda selling horses.

The mother, in silent strength, decided against attempting escape and instead gathered the children in front of a burning fireplace, which signaled rescuers. The three were finally carried to high ground accompanied by their swimming dog.

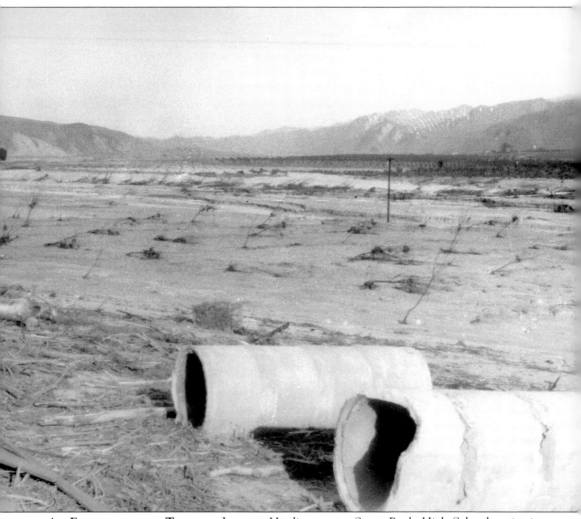

AN EVENING AT THE THEATER. Jeanette Hardison was a Santa Paula High School senior in 1928. She traveled to Los Angeles on the night of March 12 with her mother, sister, and brother to see her sister, Helen, appear in a play. Her family drove home to Santa Paula through Castaic Junction in their Packard sedan just before midnight. Less than an hour later a wall of water as high as 110 feet swept Castaic Junction "as bare as a pool table."

"We spent a little time visiting with Helen after the play," Jeanette recalled. "If we had stayed any longer we would have been washed down the river."

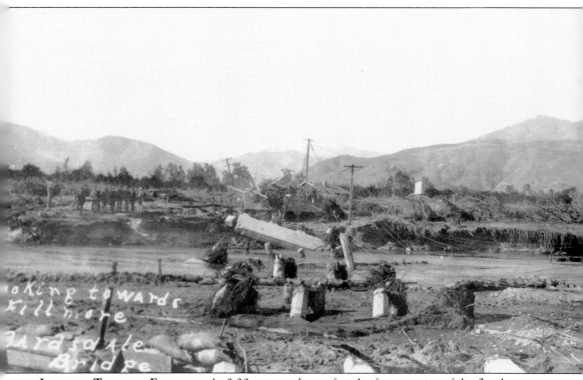

LOOKING TOWARDS FILLMORE. At 2:20 a.m., an hour after the first warning of the flood came out of Los Angeles, water struck the Bardsdale Bridge traveling at more than 12 miles per hour, 30 miles below the dam. The Fillmore telephone operators had started frantically calling the townspeople to warn them of the flood. Only minutes were left when the warning was telephoned to the Basolo family living on the banks of the river in three houses one mile south of Fillmore on a 219-acre orange and alfalfa ranch.

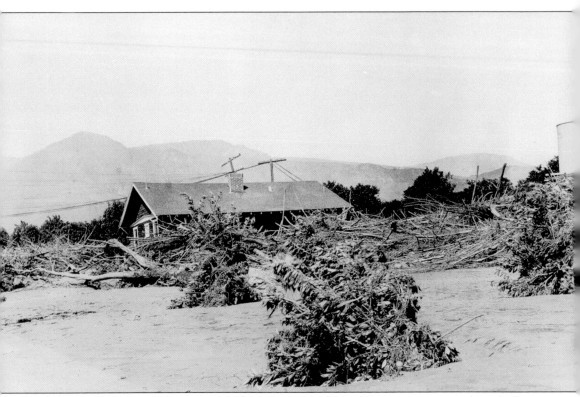

BISMARK BASOLO OF BARDSDALE RECEIVED THE CALL. The warning came by telephone from the night operator in Fillmore. Water was over the highway at Saugus and it might be a good idea to get out. Bismark and George Basolo and their sister and brother-in-law and their children piled into cars and drove for higher ground.

"I just barely made it," said Bismark. "The water was starting to come up on Chambersberg Road and I had to swerve to get around it. I could hear the water roaring behind me." The body of Birsmark's brother George was found three days later a mile and a half downstream.

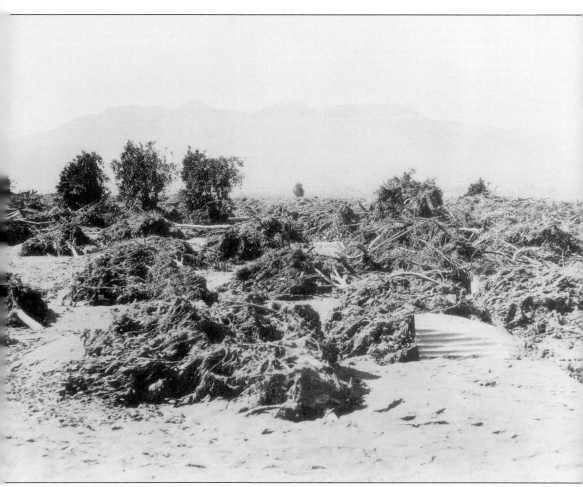

A Thwarted Escape Across the River. Dead bodies were stacked in piles at the French and Skillin mortuary in Fillmore. The bodies were washed and laid out for friends and relatives to identify. George Basolo was one of the first to be identified. He was drowned when the wave hit his car as he was attempting to cross the Bardsdale Bridge. A passenger escaped when he was thrown free of the car and washed up into an orange tree.

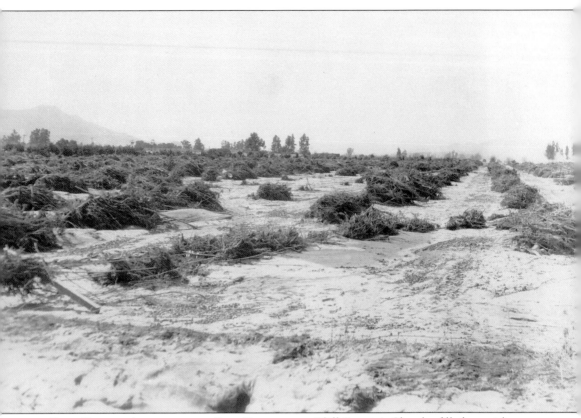

CLIFF CORWIN ATTEMPTED TO FLEE BARDSDALE. Cliff Corwin's Chrysler filled up with water so he struggled out and hung on to the hood as the flood pushed him along like a surfboard on a wave. He could hear the crest of the water above him but was unable to see anything. "There was a high fog, no stars, no moon, and all the lights were out in the valley. It was as dark as a closet," he said.

The boiling turmoil of a wave caught him and tumbled him under and dashed him into a submerged orange tree. "I was locked down there," he said. "I kicked my way loose and headed for the top of the tree. I took one gasp of air and got a lot of water and mud. I particularly remember how much mud was in the water."

Corwin hung to the tree in the water for two hours before the water began to recede. "I was struggling like a worm in the mud and the water when the first group of fellows got to me."

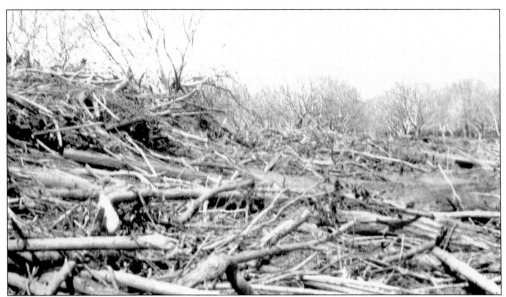

BODIES WERE GATHERED AT THE CHURCH. The Bardsdale Methodist church basement became a temporary morgue before the bodies were taken over the hill to Moorpark. All the bodies from Piru were taken to Fillmore. Every community had its improvised morgues.

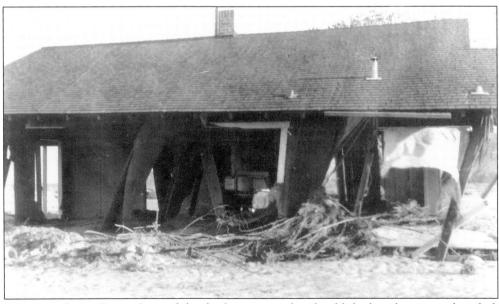

THE LIST GREW DAILY. Lists of the dead were posted and published as they were identified. Bodies were brought to Diffenderfer's undertaking parlor in Oxnard, Baker's in Newhall, Reardon's in Ventura, a drugstore in Moorpark, French's undertaking parlor in Santa Paula, and French and Skillin in Fillmore.

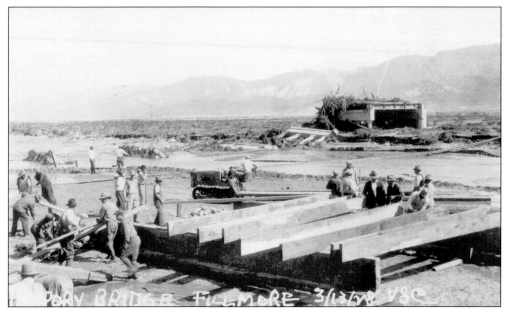

TEMPORARY BRIDGES WERE BUILT. Crews worked to reestablish road and bridge links between Fillmore on the north and Bardsdale on the south of the Santa Clara River.

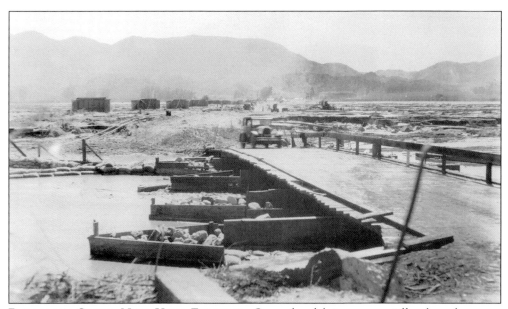

BARDSDALE COULD NOW VISIT FILLMORE. Once the debris was partially cleared away a temporary bridge and road made contact possible between Bardsdale and Fillmore. This view is looking south toward the Bardsdale area.

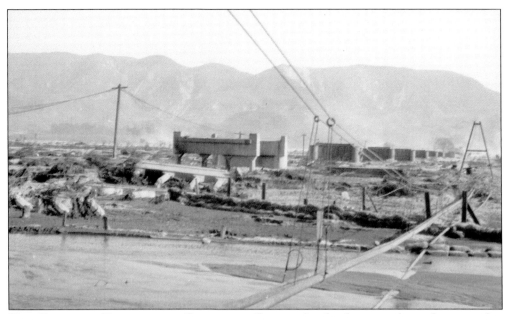

THE CONCRETE PIERS OF THE BARDSDALE BRIDGE. In the foreground are the pipes that carried oil from the fields on the south side of the river. Trusses from the bridge were found over two miles downstream.

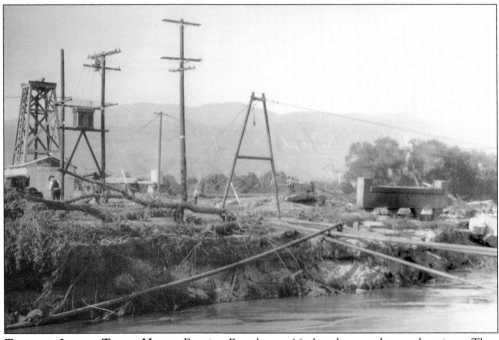

TRAPPED INSIDE THEIR HOME. Bernice Boardman, 16, lost her mother and a sister. They climbed onto the kitchen sink and out through a window. The mother and sister were on one gable roof and she was on the other. The house careened down the stream until it hit a road. There the two sections of the roof split apart and that was the last she ever saw of her family.

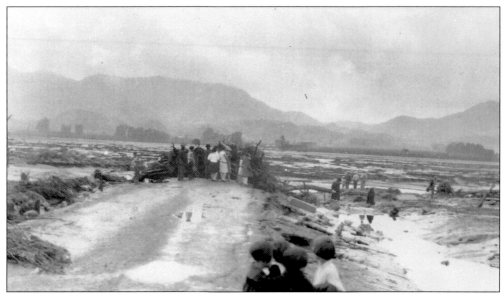

An Escape Through the Roof. A Fillmore man, realizing his home was flooding, blew a hole in the roof with his shotgun and hoisted his two daughters and wife out onto the roof. The roaring waters soon ripped the house off its foundation and carried it downstream. Tragedy was averted when the house caught in a grove of four sycamores where it held fast until the waters receded.

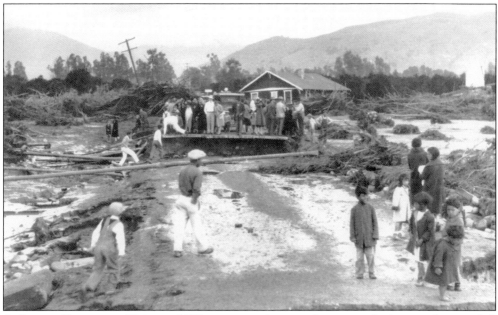

A Crowd Gathered. Citizens of Fillmore came down to the river to look over what was left of the Bardsdale Bridge. This view is looking north toward the Fillmore side.

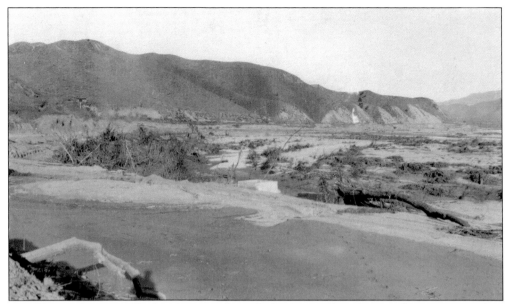

THE TRAINS RETURN. Railroad service through the Santa Clara River Valley was restored on Tuesday, March 27 when an eastbound passenger train left Fillmore at 7:40 a.m. More than 20 miles of Southern Pacific line through the valley was either washed out or deeply buried by the flood. The damage amounted to between $250,000 and $300,000, according to estimates.

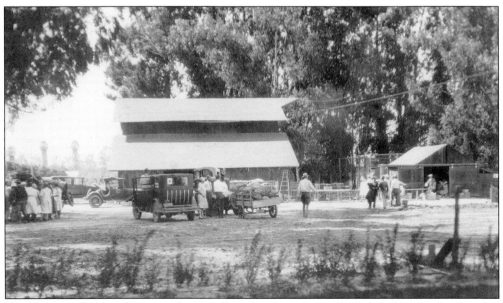

THE BURSON PLACE. This was the Red Cross headquarters in Bardsdale. Nearby the Cowden family had moved onto a ranch just five days before the disaster. All were lost. E.H. Borden had moved to Oxnard from that same ranch with his family just a few days before the Cowdens moved in.

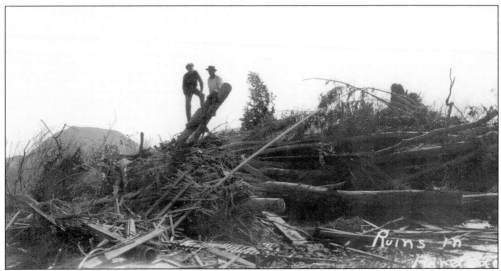

FILLMORE CLEANS UP. Clean up was being undertaken by Associated General Contractors under the direction of the L.A. Citizens' Restoration Committee. Paul N. Boggs moved into the devastated area between Piru and Santa Paula with 11 complete contracting units, comprising 56 caterpillar tractors, 10 clamshell steam shovels, 24 trucks, 2 6-wheeled trailers, 24 stone boats, 6 portable buzz saws, 7 portable brush burners, and 1,300 men.

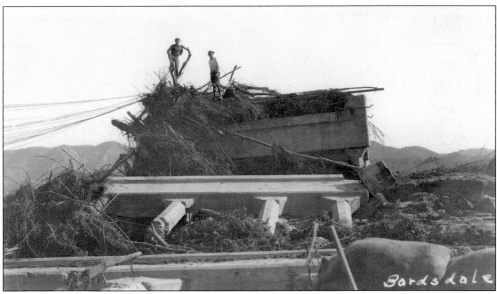

WHAT ABOUT HOBOS? There was speculation about the old men who were wont to tramp the highways, camping in culverts and under bridges, who may have lost their lives in the flood. The general belief was that a considerable number of these aged mendicants would never be seen again trudging their weary ways along the pavements, headed for no place in particular but merely going somewhere.

60

THE AGRICULTURAL LOSS. Some of the outstanding agricultural losses were suffered by John McNab, who lost 65 acres of young orange trees and some apricots at Fillmore; Ralph Dickinson, Santa Paula Lemon Company, almost total loss; Dan Emmett, 15 acres of young citrus, loss estimated at $20,000; Stork Ranch, Bardsdale; A.A. Rubel Ranch, Earl Balcom Ranch, Fleisher Ranch, Edwards Ranch, and many others.

FIRES BURNED THROUGHOUT THE VALLEY. Dead stock was placed in huge piles at Fillmore and then burned. Scouts there were locating the stock and placing flags near the bodies they found. Trucks then did the mop-up work.

61

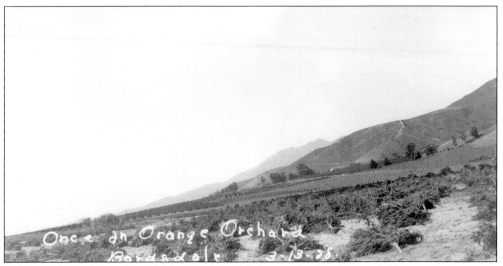

A TEEN'S WILD RIDE. Pete Bebb, 13, of Bardsdale met the flood about 2:20 a.m. As the water got deeper he moved to the roof of the house. Eventually the house went and he jumped into the flowing water. He soon grabbed a smudge pot floating past him and rode it to the east side of Ventura. He was the lone survivor out of his family of five.

SOME OF THE LOSSES. Over 24,000 acres of fertile land were swept away. Over 140,000 trees were destroyed or damaged. Approximately 1,200 homes were damaged, 909 totally destroyed. Over 100 water wells had to be re-dug. Seventeen miles of pipelines had to be re-laid and twelve miles of ditches had to be re-dredged. One hundred miles of fences were rebuilt. Over 10,569 acres of agricultural crops were swept away.

A LIFESAVING SMUDGE POT. Dillard McCarty and his brother lost both their parents in the flood. The boys went adrift on a floating roof. It was soon torn apart and they had to grab floating objects. Dillard found a smudge pot to be very flood-worthy. He was found with great lacerations across his legs and body and lying in the upper branches of an orange tree after the water subsided.

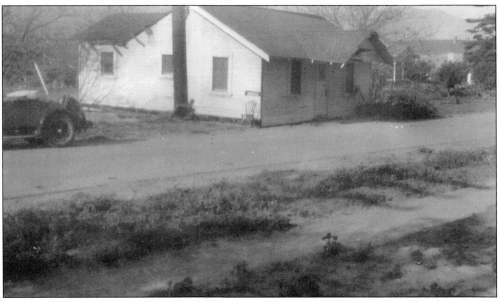

STATIONMASTER CARL DICKINSON VIEWS THE DISASTER. "We went down by the women's club and could see houses floating down the river. One grounded right near where we stood and a woman came ashore, the most bedraggled person I'd ever seen. The poor soul had been asleep when the flood swept her home off its foundation and started down the river."

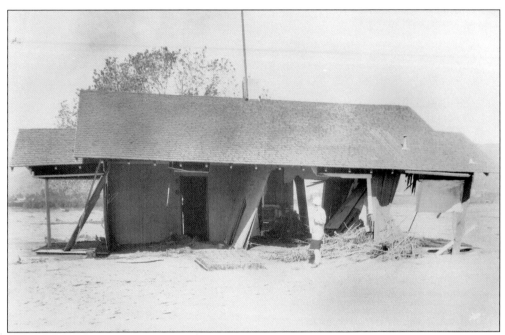

ANOTHER KIND OF WARNING WENT OUT. Notice was given to all citizens injured, physically or financially, by the flood in all towns to beware of shyster lawyers who were reported to be circulating about asking for the people to give them their cases against the city of Los Angeles. A.L. Shively, a Santa Paula banker, informed the newspapers that concerted action would be taken by the county if such was necessary.

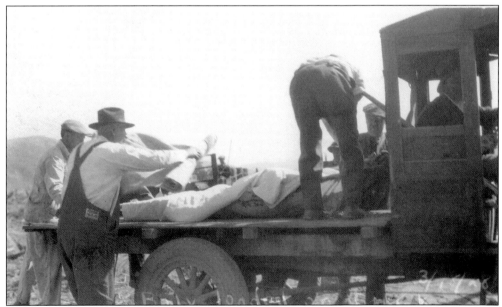

LOADING BODIES ON A WAGON. Harry Lechler of Piru recalled going down to the river just hours after the 60-foot high wall of water had diminished. He watched in horror as men pulled bodies out of the mud, stacked them on wagons and transported them to a dance hall in Piru that had been set up as a temporary morgue.

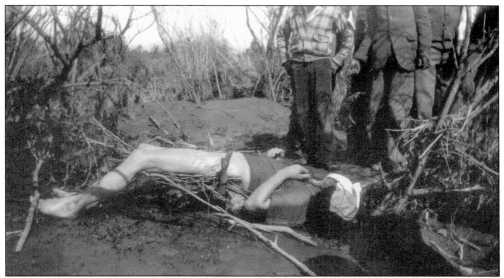

THE GRIM JOB OF DEALING WITH THE DEAD. Oliver L. Reardon was the Ventura County Coroner and Public Administrator and in that capacity he handled and oversaw the remains of all lost in the disaster. His sons, Joseph and James, helped with the job. As cranes advanced down the river bed separating the debris they were called upon to remove the human remains that were uncovered, sometimes two a day, for months on end, through September. The remains were taken to Reardon's Ventura mortuary and photographed for possible future identification.

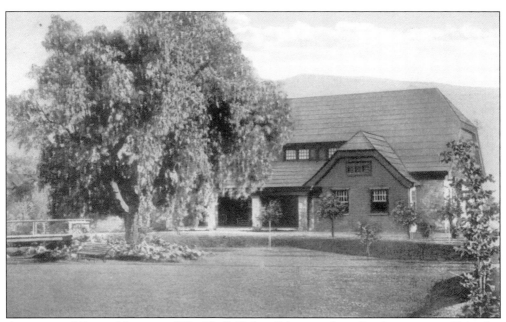

ATTENTION! EBELL MEMBERS. "The Ebell Club will be open from Sunday noon until Monday noon to receive flowers for the funeral of the flood victims to be held Monday, March 19. The flowers may be brought in any quantity and a committee will be on hand to arrange them. Flowers, even in small quantities, are requested." Grace Thille, President.

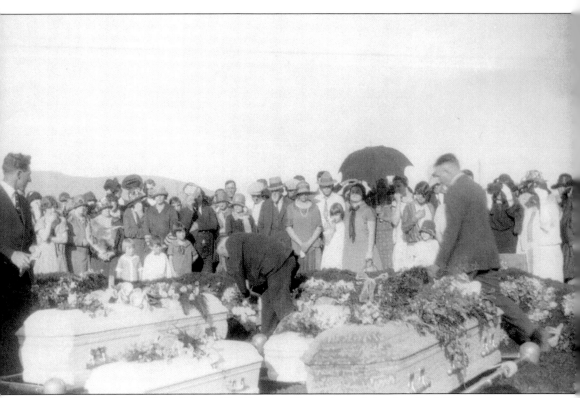

THE DEATH TOLL WILL NEVER BE KNOWN. The estimated death toll of 450 may be hugely undercounted. The actual number of lives lost will never be known but some estimates push the count closer to 600 because so many bodies were washed out to sea and never counted. There were also many migrant Mexican farm workers who were never accounted for.

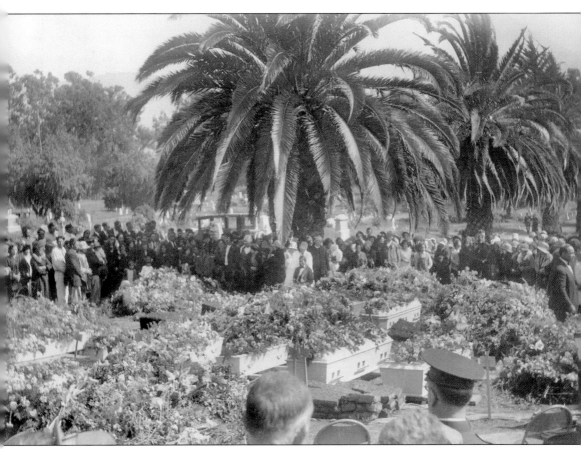

SANTA PAULANS PAY LAST RESPECTS TO VICTIMS. Seven truckloads of flowers made into wreaths by 300 local women were delivered to the cemetery and draped upon the fourteen caskets of victims of the flood for the memorial service at 2 p.m. on Monday, March 19. Father John J. Cox of St. Sebastian's church delivered the eulogy before a gathering of 2,500. All the ministers of the city took part in the services that were described as beautiful in their simplicity. Miss Arley Mott provided the musical program that concluded with "Abide With Me" and a Salvation Army bugler playing taps.

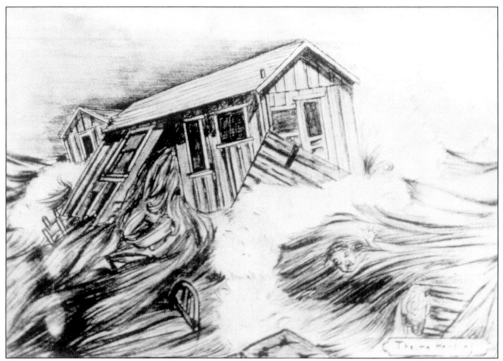

AN ARTIST'S RENDERING OF THE FLOOD. Since the floodwaters did most of their damage in the dark of night there are no photographs of the destruction as it was happening. This artist's rendering of a house being swept away by the massive power of the flood gave people some small idea of what it must have looked like.

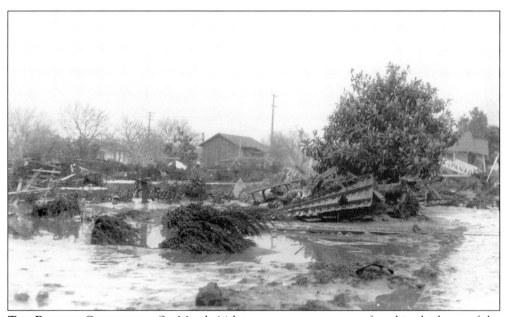

THE RESCUES CONTINUED. On March 14th two more persons were found in the heart of the flood area. The first was a child clinging to an orange tree near Santa Paula and the second was a man buried up to his neck in muck and slime, although the breath of life was still in him.

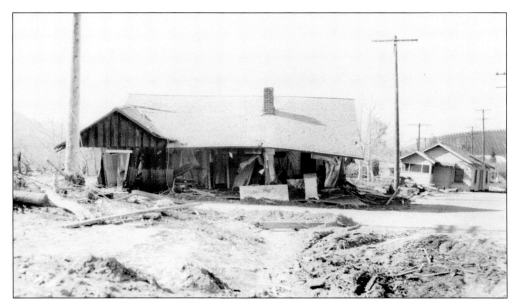

CONTRIBUTIONS FLOWED IN. Members of the Santa Barbara Women's Club collected $467.56 for flood relief work at their regular meeting held at the Lobero Theater.

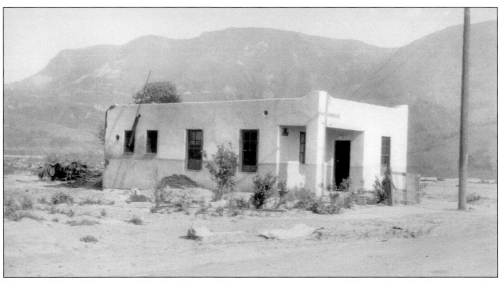

BODIES WERE WAITING TO BE SENT. There were at one time 35 unidentified bodies in the morgue at Santa Paula. At the train depot were 17 bodies ready to be sent out on one train, some as far as Vermont. These were from Edison Camp. No visitors were allowed in town for several days and residents were required to have passes if they went around town.

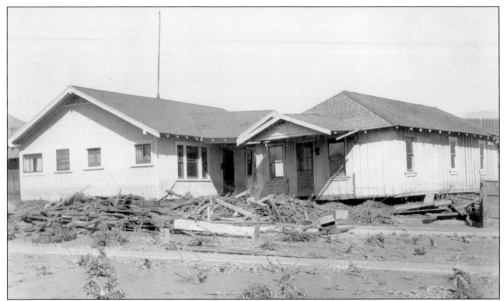

A ROTARY TELEGRAM. Leo A. Smith, secretary of the Santa Paula Rotary Club, received the following telegram: "We extend our deepest sympathy to you and your community because of the flood disaster. Our board of directors authorized a relief contribution to be made through the American Red Cross." Richard G. Wilcox, secretary, Rotary Club of Los Angeles.

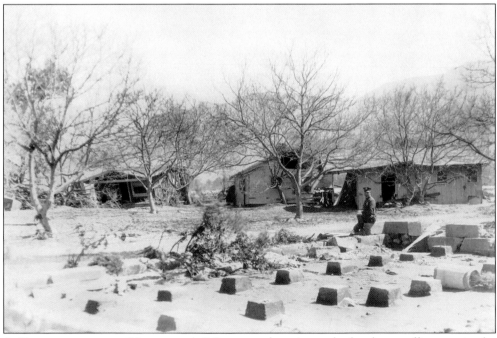

A TELEGRAM FOR THE MAILMAN. A.P. Lang, rural carrier at the local post office, received a telegram from H.H. Bellany, Fourth Assistant Postmaster General, asking about the conditions of the roads for rural delivery. Lang stated that he was able to deliver mail all along his route, where houses remain, but had been forced to wade in some places. Some of his homes had been swept away.

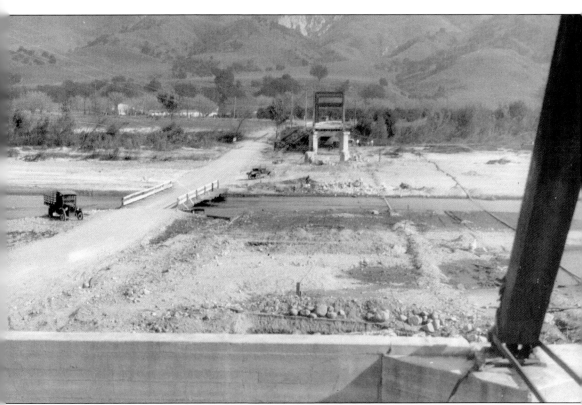

A TEMPORARY ROAD AT THE WILLARD BRIDGE. Ventura County Engineer Charles Petit estimated the damage to highway and bridges in the county at $152,000. The county steam shovel was soon put to work filing in the gaps cut into the highway. His estimate included highway pavement above Piru, $10,000; Willard Bridge, Santa Paula, $40,000; Bardsdale Bridge, Fillmore, $80,000; Saticoy Bridge approach, $2,000; and Montalvo Bridge, $30,000. The most extensive highway damage was at a point just west of the county line near Edison Camp. The heaviest bridge damage was to the Bardsdale Bridge, which was taken out entirely.

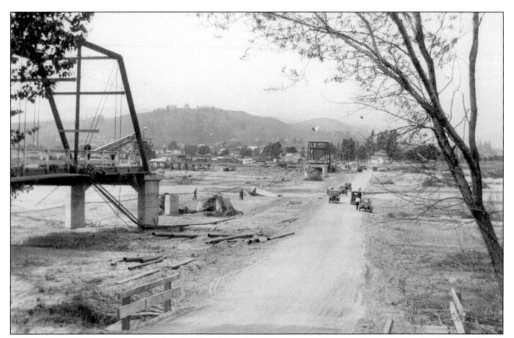

MRS. WILLARD'S BRIDGE. The Willard Bridge was opened to traffic across the Santa Clara River on July 4, 1920. The bridge was built by popular subscription at a cost of $57,500. Mrs. Harriet Willard paid $7,500 of that amount. In gratitude the town of Santa Paula named the bridge in her honor. The flood carried away two of the bridge spans. The spans were replaced in 1929.

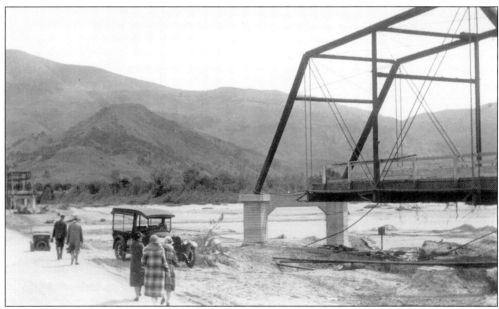

RIDING A DRUM TO WORK. About 30 feet of the north approach to the Willard Bridge washed out. The oil companies needed to get their crews back and forth across the river so they ran a steel cable from the north end of the bridge across the stream and anchored it to firm ground. A large hanging drum was rolled along the cable to carry oil workers across the river.

72

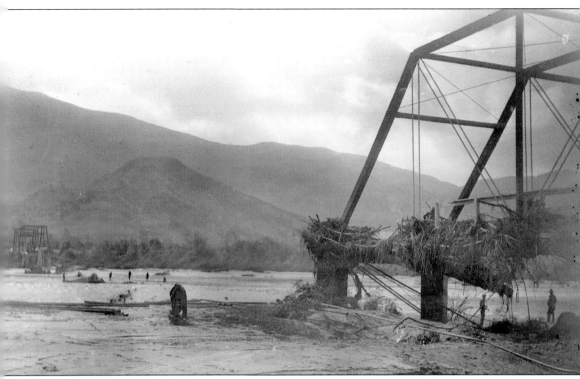

THELMA MCCAWLEY AT THE WILLARD BRIDGE. Two men were searching for victims near the Willard Bridge when they thought they heard the cry of a peafowl. Taking a closer look they found 13-year-old Thelma McCawley in a pile of brush. The torrent had swept her 10 miles downstream from her Bardsdale home. She wore only a light coat her mother had handed her a few seconds before her home was washed away. This shivering little girl with big, terror-stricken eyes was wrapped warmly against the March winds and taken to South Grammar School where rescuers were working frantically to save the lives of scores of flood victims.

Mrs. Potter, a practical nurse, took Thelma to her South 10th Street home and nursed this rescued orphan child back to health through the pneumonia she contracted and the case of measles she already had when the flood swept her away.

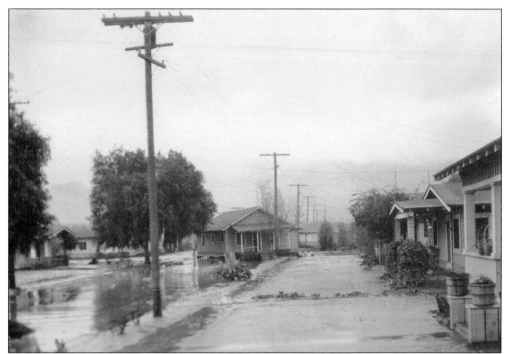

A COMMOTION AWAKENED TOM RILEY. Horns sounded as he walked with his family up the hill from his 7th Street home to the high school and presumed safety. There they waited, and waited. Finally they heard the water taking out the Willard Bridge. "You could hear the cracking and groaning and the snapping of the gas lines across the river and Union Oil's siren was wailing away," the 20-year-old recalled.

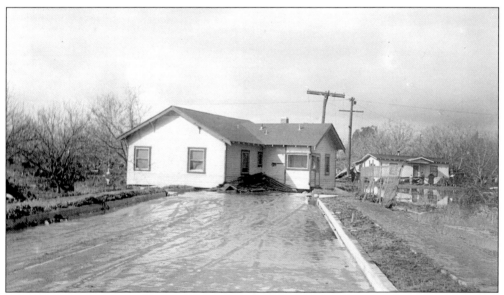

WE DIDN'T EVEN KNOW THERE WAS A DAM UP THERE. "As far as we knew, it could have been coming from the ocean. We didn't even know from which direction it came. We didn't know if we had five minutes or an hour," Tom also recalled.

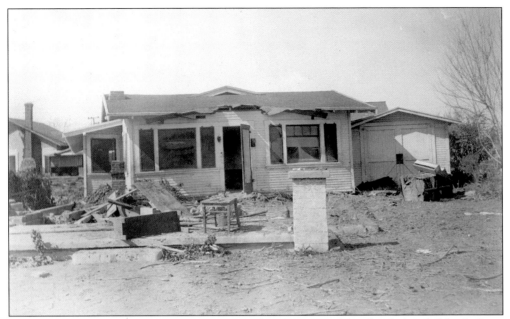

THE GARAGE WAS NEVER LOCATED. At daybreak Tom and his family headed back down the hill. They stood in awed silence and viewed homes strewn in all directions. Their home, a lemon yellow California bungalow, was gone. Only the foundation was left. It would later be found on the grounds of Isbell School and returned to its foundation. His mother would later complain that the doors never closed properly.

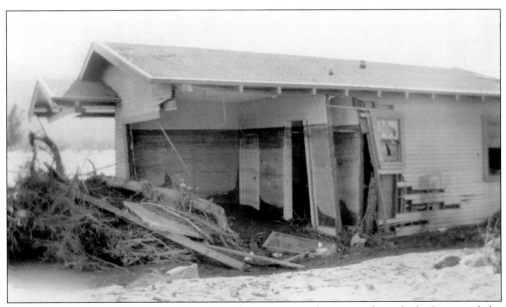

THE CORNER WAS KNOCKED OFF. The house across the street from Jack Creese of the Union Ice Company loosened from its foundation and a corner of that house was knocked off, exposing the bedroom and making it possible for all the furniture in the bedroom to be carried away by the floodwaters.

75

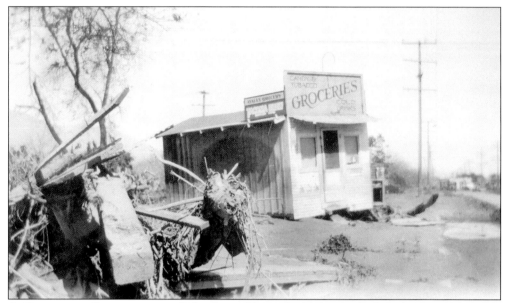

A CHILDHOOD RECOLLECTION. "The first inkling of any danger, looking back, was, I guess, getting picked up by my father and being transported up to Aliso Canyon." Jess Victoria, age 6 at the time.

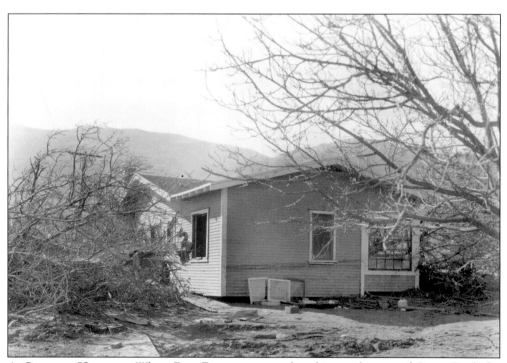

A GHASTLY HARVEST. When Dan Emmett returned to his ranch west of Santa Paula he discovered seven bodies. The body of a 10-year-old Mexican boy was found high up in the branches of a tree where he had been washed by the water.

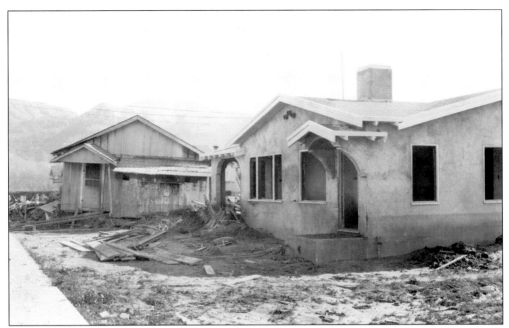

SOME MINOR DAMAGE ON HARVARD. The W.R. Starr home on Harvard Boulevard was not moved from its place but was flooded and other buildings and pieces of furniture were deposited in the yard. The loss to the Starr family was several hundred dollars.

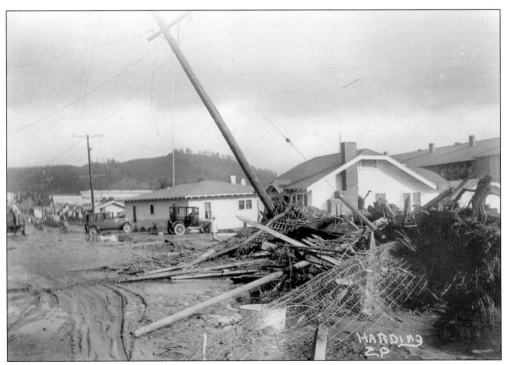

WHAT ONE REPORTER WITNESSED. A dead horse lying in the street, a black cat high up in the upper branches of a tree, stray dogs, phonographs, sewing machines, oil stoves, beds, and mattresses are just a few of the hundreds of testimonials of the violence of the flood.

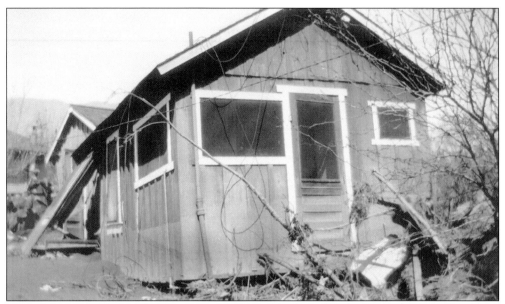

THE HOMES ABOVE MAIN STREET WERE SPARED. Three hundred and thirty-six homes in the section of Santa Paula below Main Street were either wholly destroyed or damaged by floodwaters. Of the 336, nearly 200 were totally destroyed.

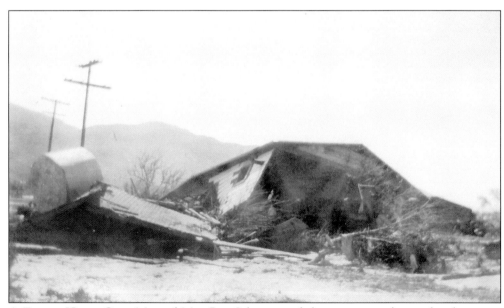

A FAMILY HELPS OUT. Mr. and Mrs. Bert Johnson and their son moved in with relatives in Santa Paula since their home was completely wrecked on Harvard Boulevard. The house was moved several yards and then deposited in a mud bank.

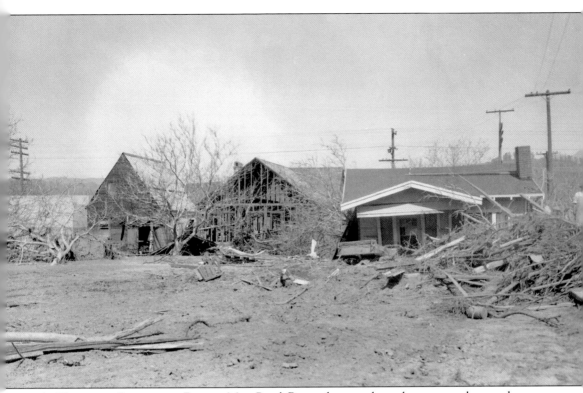

A Night of Panic for Pearl. Mrs. Pearl Barnard stepped out her screen door and was gripped by the flood and whirled around like a ball. She found herself drifting down the river, sitting on a rather sharp-edged beam, wearing only her nightgown and wristwatch. She held on and braced herself until about 5 o'clock in the morning. As the water subsided she found she was on the side of an old barn and not in the middle of the river anymore but up against a big tree not far from Harvard Boulevard on the south side of the street. She had been there all the time, not floating as she had though she was. At dawn she heard voices and called out. Two young Mexican boys came and rescued her.

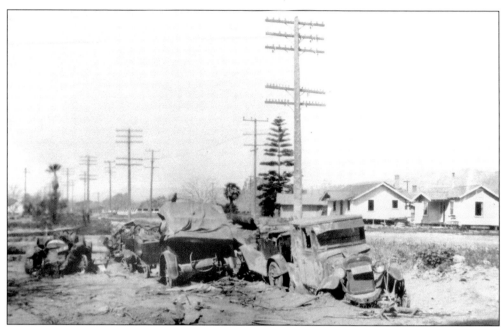

A Panic on South Fourth Street. Mrs. Robert Matthews was alone in her house when warned. In her rush and panic to get her car out of the garage she lost her keys in the dark. Neighbors drove her to the safety of the hills. Upon returning home she found her house swept off its foundation and another house from 7th Street piled up in her front yard.

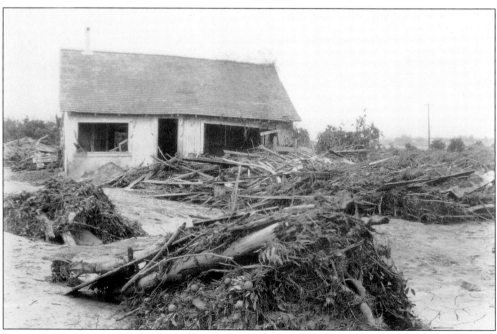

A Log Jam In Santa Paula. In a narrow place above Santa Paula the flood left a log jam of citrus trees, telephone poles, houses, and miscellaneous debris. It was 200 feet long and 20 feet high.

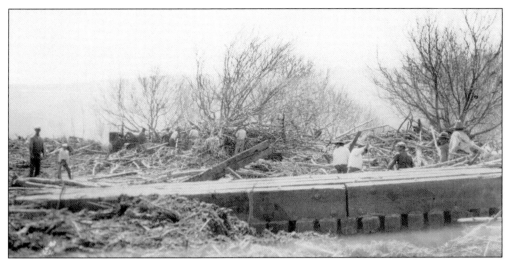

Don't Believe Everything You Read. "The flood was unleashed when the Los Angeles aqueduct crumbled under the pressure of a cloudburst in the High Sierras, poured 38,000 acre-feet of water into the river basin, sweeping towns before it in its wild dash to the sea." From an erroneous *United Press* item of March 13. It is true that this portion of the Castaic Bridge floated to Santa Paula.

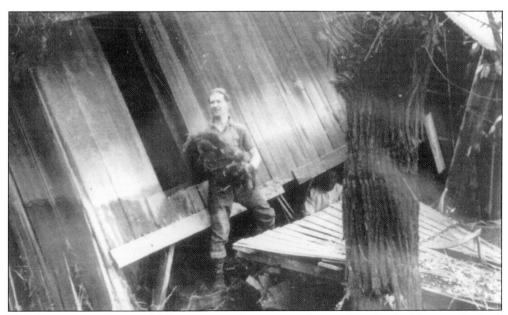

The Paperwork Begins. "All persons owning property damaged by flood within city limits of Santa Paula are instructed to report on Tuesday, March 20th, or as soon thereafter as possible, at the City Hall, prepared to give Lot Number and Tract Name, and detailed description of buildings and nature of damage." I.B. Martin, Chairman of Board of Appraisers.

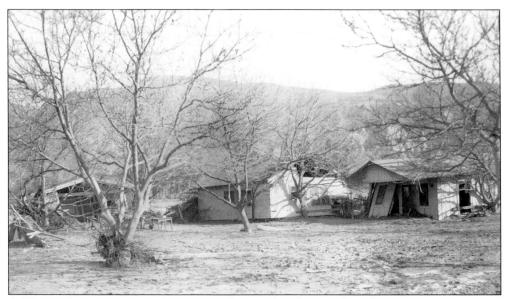

A HAVEN AMID DISASTER. A man pounding on her door awakened Herminia Ramirez, 21, at 6 a.m. on March 13. She and her two daughters were sleeping peacefully at their small three acre spread located one half mile above the river. Her concerned father was the man at the door.

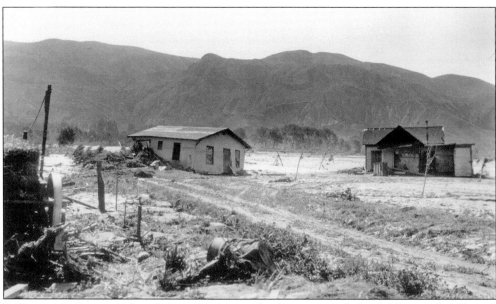

A FRIEND IS LOST. Although Herminia's own family was spared she did lose a close friend, Carlotta Zavala, from Piru, who died tragically while trying to save her infant child from the muddy waters. Carlotta's body was found the next day, still clutching her infant child with $500 in her possession.

82

OIL AIDED THE BURNING. Oil sprayers were furnished by the State Dept. of Agriculture. Because of the number of animal carcasses and other decomposing debris it was necessary to get rid of these mounds as quickly as possible.

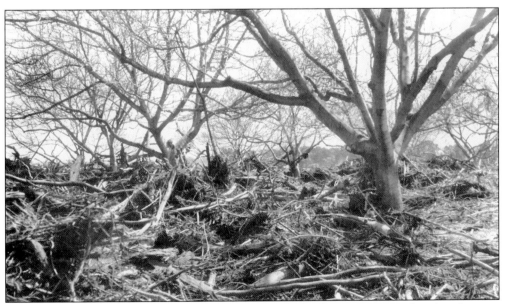

ONE OF THE MANY UNKNOWN DEAD. The headless body of one victim was found in the river bottom near Santa Paula. Because of the battered condition of the torso, the Ventura coroner was unable to determine whether the victim had been a man or a woman.

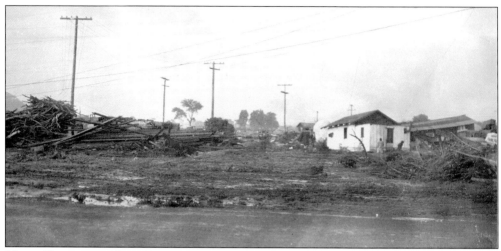

MOSES RETURNED HOME TO HELP. Moses Levario, 21, hosed down bodies with hot water so they could be adjusted from their stiff, muddy, and awkward positions. They would clean their faces and then hose them down again with cold water. "We would arrange the bodies on large pieces of paper like ears of corn in a row so that families could go and identify their deceased."

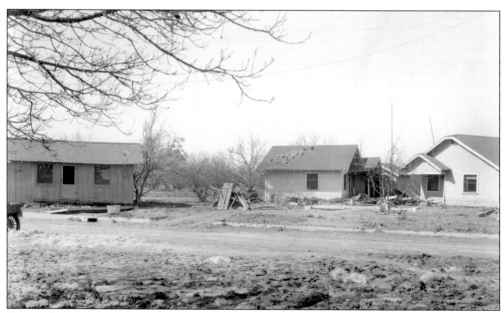

RELIEF ARRIVES. James Procter, president of the Santa Paula Chamber of Commerce, ran a relief station after the San Francisco Earthquake. He reported that the Salvation Army arrived first and asked, "What can we do?" A couple of days later the Red Cross arrived and said they were taking over. Procter and Charles Teague told them, "No, we're in charge, but you can set up shop," and they did.

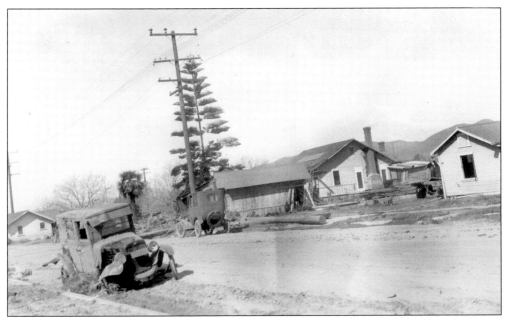

THOSE TREES ARE BUT A MEMORY. The arcade of eucalyptus trees that once lined Highway 126 were each planted as a memorial to one of the flood victims.

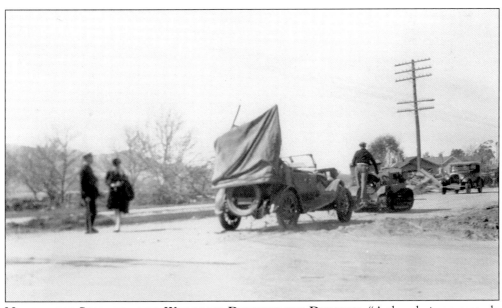

NEWSPAPERS SEARCHED FOR WORDS TO DESCRIBE THE DISASTER. "A thundering crescendo of a cascading avalanche of swirling water."

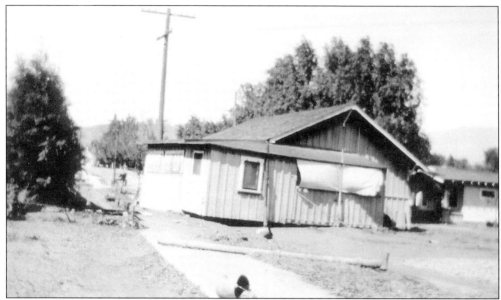

THE FLOOD WAS GRADUALLY SLOWING AS IT HIT SANTA PAULA. The forward speed of the flood wave by now had decreased to about 11 miles per hour from its original 18 miles per hour.

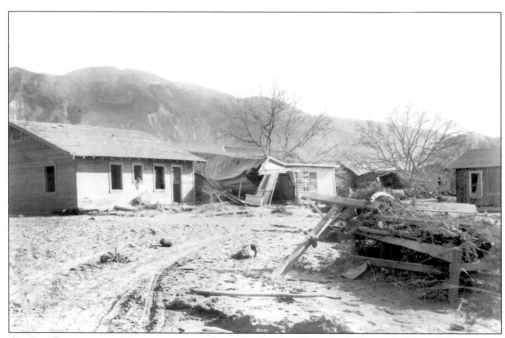

ON ITS RELENTLESS MARCH TO THE SEA. As the flood reached the end of South Mountain it overflowed to the south and flooded well below Vineyard Avenue. It apparently followed ancient channels toward the Oxnard Plain.

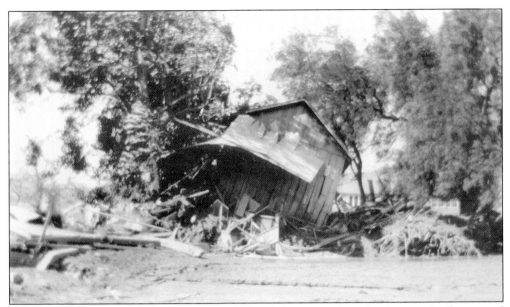

THE CRUEL HAND OF FATE. Fate played cruelly with one rancher who foresaw the danger and thought he was out of its reach. He loaded his three children into a small automobile and then stopped for a moment to warn a neighbor. When he turned back to his car it had been swept away, human cargo and all.

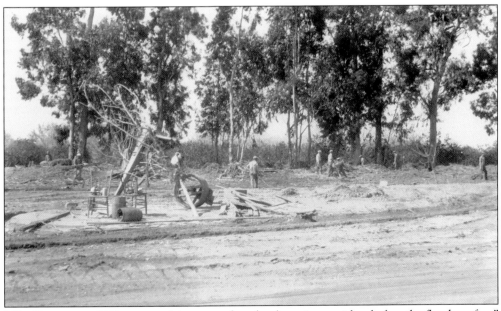

I DO REMEMBER. "When something was referred to later, it was either before the flood or after." Nell Anlauf, 23 at the time of the disaster.

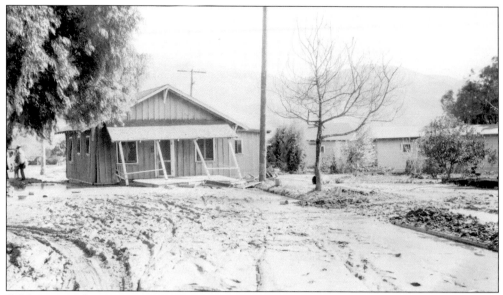

A MICHIGAN GUEST IS SWEPT OFF THE PORCH. H.M. Jones and his wife got the warning at their Harvard Boulevard house and hurriedly collected a few possessions and rushed to their car. The car stalled. A houseguest from Michigan, Mrs. Mills, was following closely behind them but was swept off the porch by the rushing waters and swept against a tree. Two fellows passing by rescued Mrs. Mills.

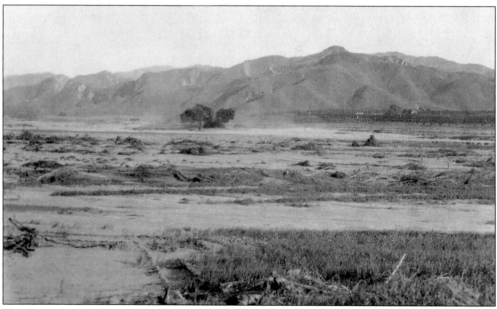

THE LADY OF THE DIAMONDS. One victim had on a diamond necklace, earrings, and rings. She was going to visit her sister in Los Angeles. She had driven from Oakland intending to surprise her sister. She and her 5-year-old son stopped for the night at a motel in Castaic. Her son's body was found a few feet from the motel and her body was carried 30 miles downstream.

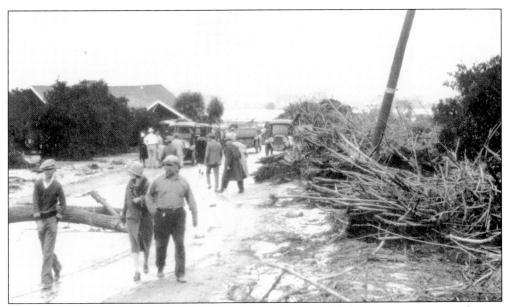

AN EYEWITNESS DESCRIPTION. "It is just one great scene of devastation, at some places a mile and a half wide, that stretches clear to the sea. Thousands of people and automobiles are sloshing through the mud and debris looking for the dead. Bodies have been washed into the isolated canyons. I saw one alive stuck in the mud to his neck."

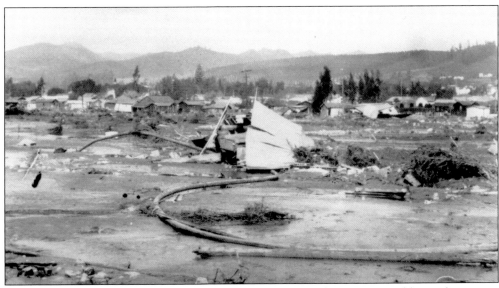

THE APPALLING RESULTS OF THE CATASTROPHE. "As far as you could see there were uprooted trees, fragments of barns and farm buildings, fence posts wrapped in yards and yards of tangled barbed wire, carcasses of cows, dogs, chickens, horses, and slabs of concrete, perhaps from the abutments of the Willard Bridge that had recently linked Santa Paula to the oil leases on South Mountain."

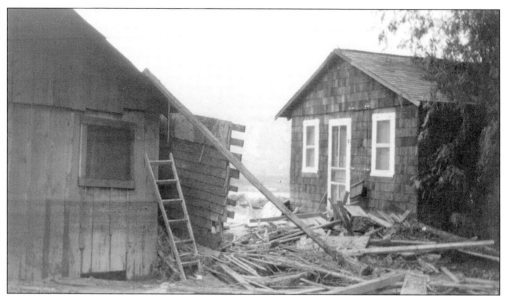

WATER, WATER, EVERYWHERE BUT NOT A DROP TO DRINK. Dr. John Crawford of Santa Paula issued the following statement. "Do not drink any water unless city water or boiled water."

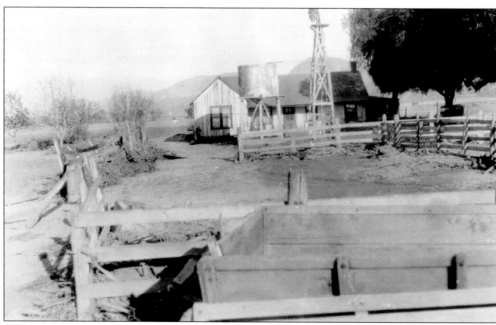

THEY ONLY LOST ONE COW. The James family dairy was down a dirt road about a half-mile from Telegraph Road on the Steckel property. Mrs. Steckel, the mayor's wife, walked down to warn them at 3 a.m. The father was already up milking the cows and could hear the mysterious roaring. They all jumped in the car and went back up the dirt road to safety.

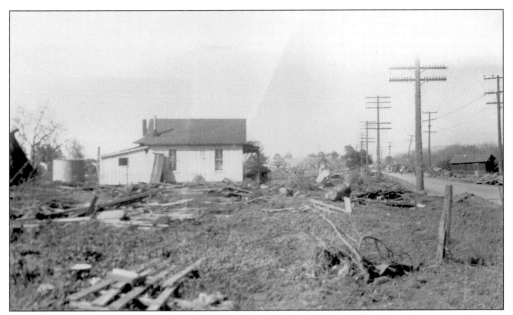

IT'S THE DAM! "My first memory of it was sirens, sirens, and sirens just screaming in the night. And the next thing I remember was my father's voice saying, 'It's the dam!'" Ruth Reddick Teague, age 7 at the time of the disaster.

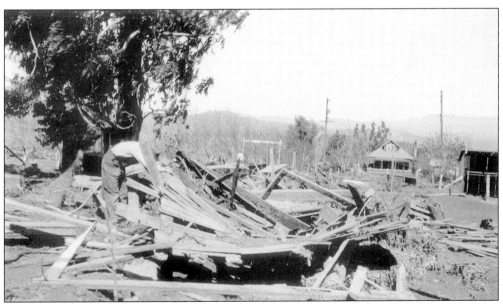

DAD CAME HOME VERY UPSET. "My dad put on his knee high boots and went down to the river to see what he could do. He pulled out many, many people and many animals. He came home very upset. Never had seen my dad so upset." May Duarte Caldwell, age 8 at the time of the disaster.

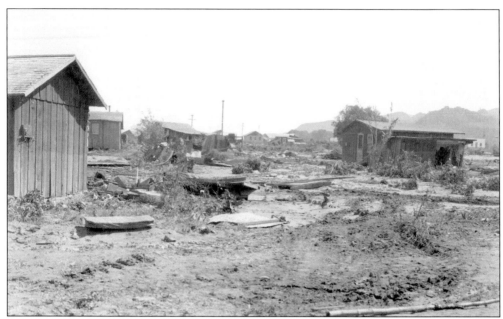

FATHER HELD HIM AS WE WATCHED. "My baby brother cried out and my dad went to pick him up to see what was wrong and he held him as we watched a wall, an absolute wave of water, come over the whole ranch." Janet Whalen Rice, age 9 at the time of the disaster.

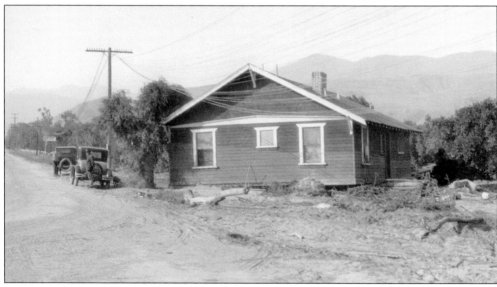

A PHONE RINGING CONSTANTLY. "We were awakened, probably one or two in the morning, with the phone ringing constantly. My dad got up to answer the phone and there were no lights so he had to feel his way all the way down the stairway and to the telephone." George Caldwell Jr., age 7 at the time of the disaster.

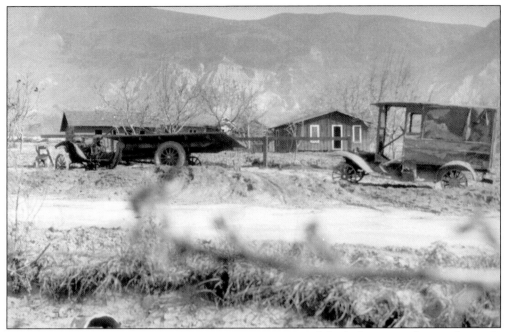

AN INDELIBLE VISUAL MEMORY. Eyewitnesses encountered freakish scenes of survival; a nude man floating on an empty wardrobe trunk, a woman in an evening dress riding along on top of a water tank and a mother and her three children clinging to a mattress stuck in a tree.

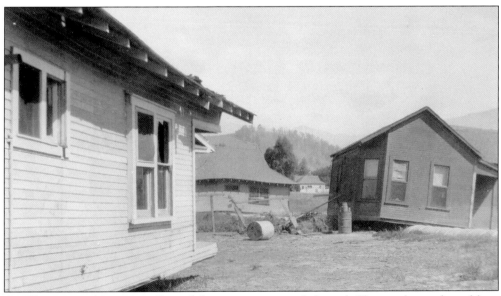

AN UNKNOWN SURVIVOR. One of the survivors was a baby girl. She was later adopted by a family in Santa Paula and given their name. They never found out who she had been.

NOTICE!

1. The Red Cross is in charge of immediate relief of homeless. Headquarters are at Old Mill Street School.

2. American Legion searching for bodies.

3. Morgue is at French's Mortuary.

4. Hospital is at Old Mill Street School.

5. Report all missing persons to the Red Cross Headquarters.

6. Relief supplies are asked for. Send to Red Cross Headquarters.

7. Chas. Millard is street superintendent.

8. Lee Sheppard, City Marshal, will sign all passes to devastated area.

THE BUSY RED CROSS AT OLD MILL STREET SCHOOL. This 8 by 11 inch broadside was posted in Santa Paula. The Red Cross would eventually collect $237,186.37 in contributions. Some of the expenditures were: relief camps, $5,796; maintenance of disaster sufferers, $29,102; food, $8,136; clothing, $46,550; household goods, $78,600; medical and nursing service, $27,179; family service, $14,195; and field supervision, accounting, and other field expenses, $10,926.

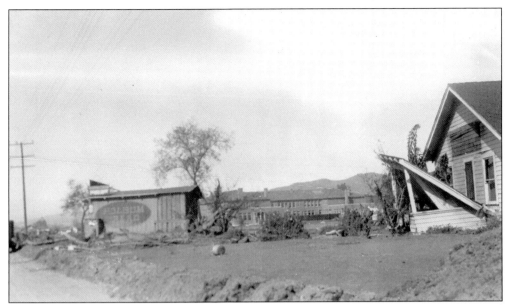

SEND BEDDING, CLOTHING, AND FOOD. The South Grammar School on Mill Street was turned into Red Cross headquarters. Mrs. Edward Loftus was in charge and she issued an appeal for food, bedding, clothing, and shoes. Mrs. Gowen was on hand at the school with a huge kettle of food left over from the Business and Professional Women's Club supper of the night before.

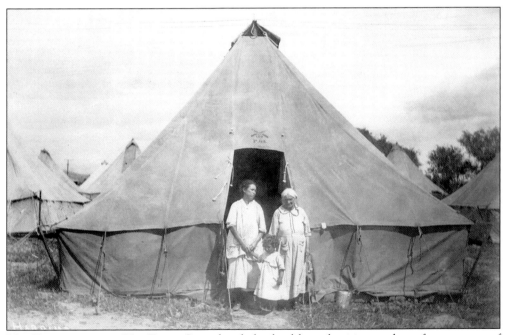

NO VACCINATIONS, NO EATS. So ordered the health authorities at the refugee camps of Piru, Fillmore, and Santa Paula. The camps were disinfected throughout and everything was done to promote sanitation. Lime was sent by the Board of Health for use in the open toilets. Dr. D. Henry Wyatt, Chairman of the Committee on Sanitation, began directing the burial of dead horses, stock, pigs, and hundreds of chickens.

5,000 Cars Daily Come Into Santa Paula. According to an estimate released March 16 by three officials in charge of issuing passes into Santa Paula, an average of 5,000 cars a day came into the city, some to identify relatives, some with supplies, and many for unknown purposes.

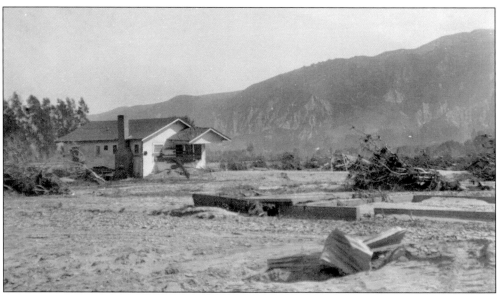

Read All About It. "Wastes Scarred by Fearful Hand of Death Stretch Under Leaden Skies in Land of Misery." A Los Angeles Times headline, March 14, 1928.

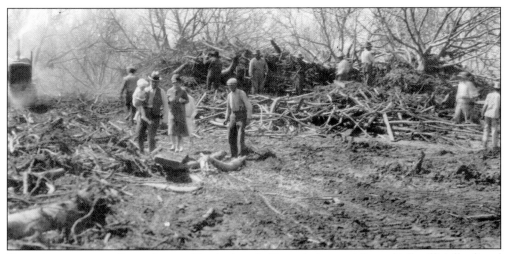

THE STAGGERING CROP LOSS. Horticultural Commissioner Albert Call officially listed the loss of 30,000 seedling trees, 343 stands of bees, and the following crop loss by acreage: 326 acres of vegetables, 832 beans, 8 pecans, 1,431 alfalfa, 15 orchards, 17 general farm, 435 beets, 21 grape vineyards, 450 barley, 92 oats, 915 oranges, 86 lemons, 465 walnuts, 265 apricots, and 5,275 pasture for livestock.

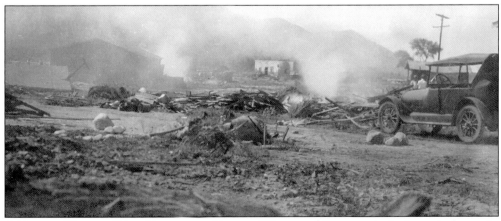

A RESCUE WORKER WHO RECOVERED BODIES. "The poor folks never had a beggar's chance."

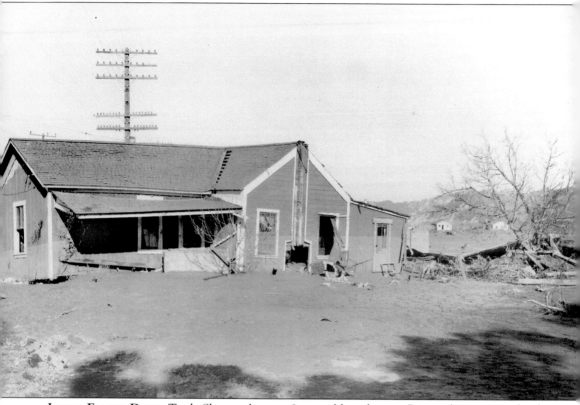

LOYAL FAMILY DOGS. Truth Sheppard was a 9-year-old student at Briggs elementary school west of Santa Paula at the time of the disaster. Her family escaped to high ground and found safety at the Vale home. The Red Cross provided shoes and clothing for her and her family.

It was three days before the family could return to their home. The entire house was lifted up at least 8 feet by the floodwaters. When her father went back wearing rubber wading boots one family dog was still on the front porch. The dog's body was covered with mud up to its neck but his head above the neck was clean. The dog rode the flood out on that porch and remained right there. The other family dog was a spaniel used for hunting in water and it was found downstream in Saticoy and returned to the family.

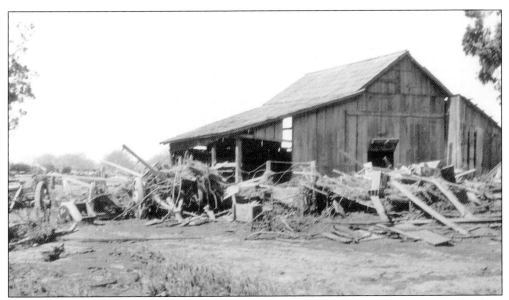

A STRANGE COINCIDENCE. Ida Hills was a teacher at a small rural school just below the dam. Her body was later found far downstream at the Sheppard property at Santa Paula. Her hair was naturally dark but when the body was found her hair had turned white. Ida Hills was Emma Vale's sister. The Vales were the family who took in the Sheppards after the flood.

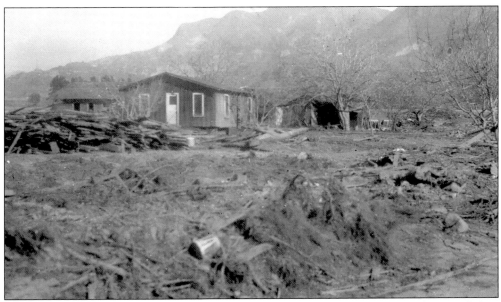

A MATTRESS RIDE. Four-year-old Esiquio Luna was awakened by his mother who rounded up the children on her bed as their roof collapsed. They were swept out of the house on their bed for miles. They survived, naked but in one piece. The mattress was finally stopped by a tree. They sat and waited for the water to recede and were eventually rescued by two men waiting on the bank.

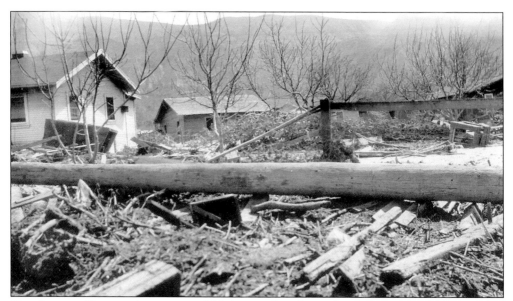

THE LOST IS FOUND. A one-year-old baby was found in a brush heap over 24 hours after the flood passed. He survived. One woman was found in a pile of rubbish. She had been there for nearly 48 hours. She would not have been found if one of the searchers had not heard her praying.

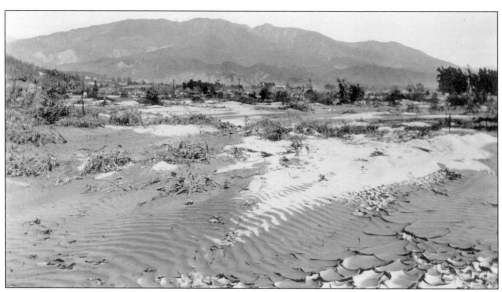

JUST LIKE MOSES. A baby girl thought to be three years of age was found playing in the mud by the Santa Clara River. She was picked up and brought to the Big Sister's Hospital in Ventura. The child's name was not known nor where she lived. She showed every evidence of having been washed downstream by the raging torrent.

A Trip On a Bed. "I was washed from the house. Not quite sure even now how it happened but I floated to a high and dry spot and climbed off the mattress of the bed I was sleeping on before the water broke up my place," commented a man trying to locate his home, which had been washed away.

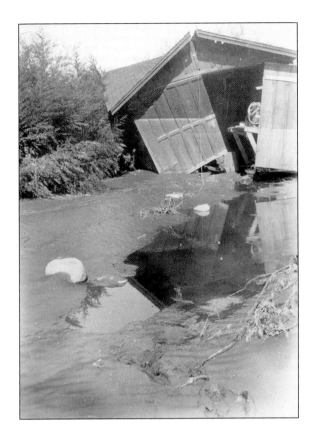

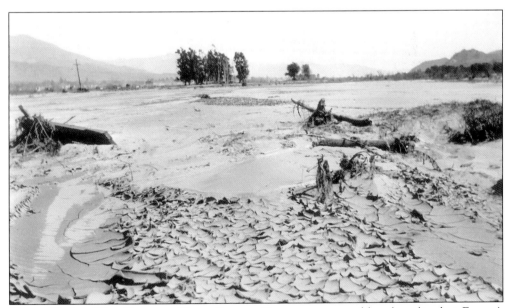

Tillie Nuñez Was Rescued Then Found. "I was two years old and we lived at Farrow's Ranch below the Saticoy Bridge. I don't know who rescued me. My family found me in Ventura after putting notices in the newspaper. Thank God I survived."

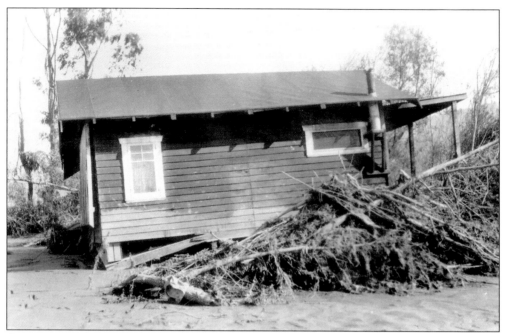

CHICKENS FLOAT ON BITS OF WOOD. The Saticoy Bridge was the only bridge in the county to stand up to the flood. The Montalvo Bridge stayed in place but an abutment washed out. As the flood reached the flatter Oxnard plain the head diminished but silt-laden water was visible miles out to sea. There were reports that chickens floated on bits of wood out to Anacapa Island.

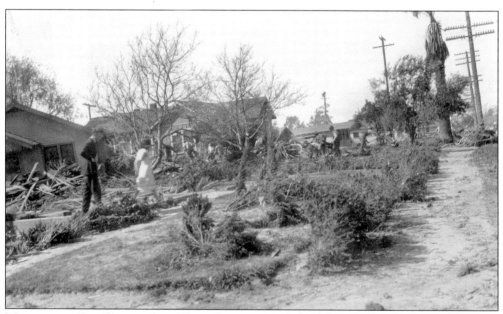

MEANWHILE, FAR OUT TO SEA. The police impressed the fishing boat *Albacore*, out of Santa Barbara, into service. An unknown number of bodies washed out to sea and one body was found as far south as San Diego. Four bodies were located near the mouth of the Santa Clara River on snags. A plume of brown muddy water extended five to seven miles out to sea.

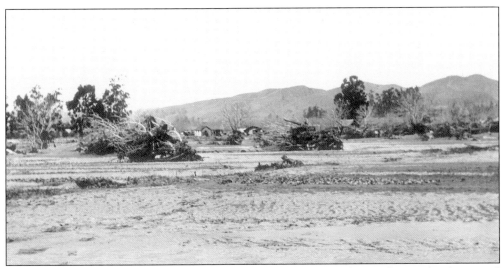

BODIES SPOTTED BY LOW-FLYING PLANES. Automobiles were often useless in the devastated area. Often the only sign of a body was a protruding hand or foot. Many of the bodies were nude or in nightclothes. Bodies that could not be removed immediately were marked with sticks driven into the ground with pieces of cloth attached. These were spotted by low flying planes.

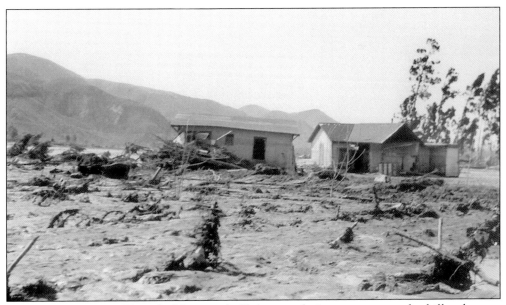

A VIEW FROM THE HILL. In Ventura, half the population went up to the hills where at dawn they saw the weird and horrible drama as debris and bodies emptied into the sea. Roy Pinkerton, then editor of the Ventura County Star, wrote: "At daybreak, from our hillside we saw the stream, filled with trees, houses, and debris, pour in a great arc over the Montalvo Bridge.

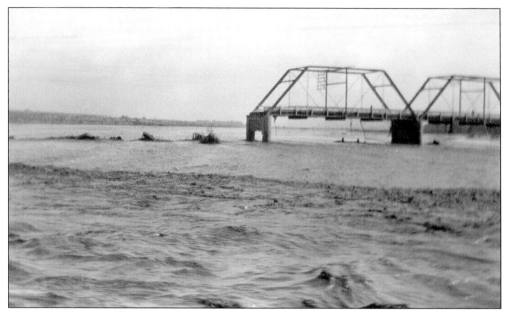

"COAST HIGHWAY BRIDGE OUT AT MONTALVO." This snapshot was taken on Tuesday, March 13 by O. Stoehrer, Box 6, Oxnard, Calif. At the flood's end, near the ocean, Highway Patrolman Ken Murphy had blocked off the Montalvo Bridge. An indignant bus driver demanded to cross the bridge. Murphy didn't budge and as they argued the floodwaters washed out 200 feet of the road approaching the bridge.

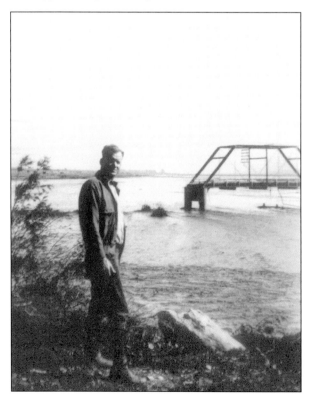

THE STORY OF A TRAMP. A tramp was camping under the Montalvo Bridge. He was wakened by shouts, sirens, and lights flashing everywhere. When he learned of the great danger he was in he grabbed his clothes and his blanket, leaving his tent and other belongings to the rushing wall of water. He got as far as one of the pilings of the bridge where he was marooned for hours.

Five

POWERFUL TRACTORS AND HARD WORKING RESCUE CREWS

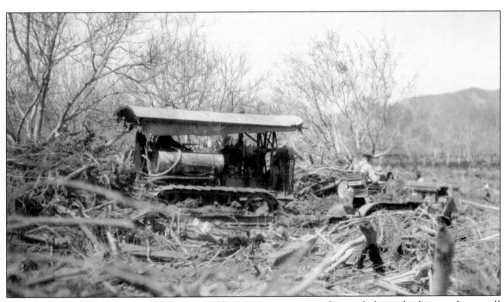

THE WORK OF THE TRACTOR. The lumbering iron tractor chugged through the muck to pull dozens of cars, trucks and wagons out of ditches, shove aside trees and debris in roadways, and push back the remains of houses that had been knocked into the streets by the force of the water.

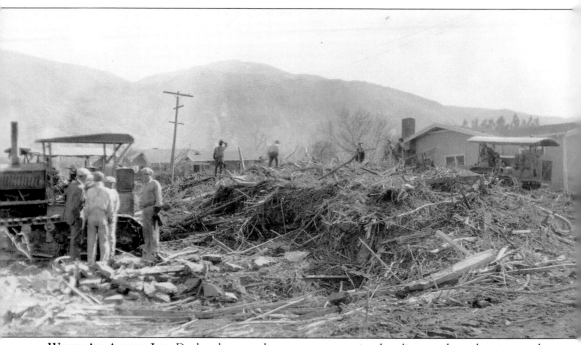

WHAT AN AWFUL JOB. Daybreak greeted a strange procession heading south to the river and the destruction. Teams of horses with mud caked bodies, men in clothes they had been in for days, trooped slowly toward the path of death and destruction. They attacked huge brush piles by throwing steel hooks into them and having horses and tractors pull the matted masses to pieces. Among the first bodies found were those of an unidentified woman in whose arms was clasped a babe of tender years. They were said to have been found in the middle of a large pile of brush in an orange grove.

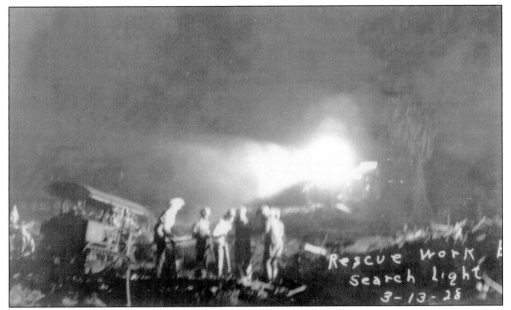

UNIVERSAL CITY AIDS IN SEARCH. Several truckloads of high-powered generators, floodlights, spotlights, and sunarcs were sent from movie studios in Universal City to aid in the search for bodies at night.

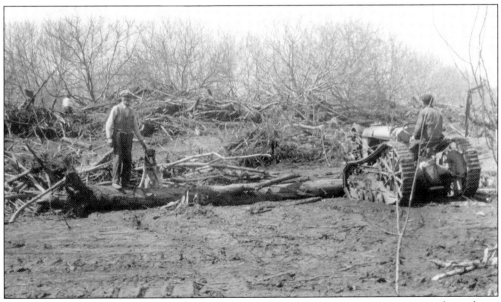

WHAT AN ODOR. When thousands of dead animals began to rot, crews were sent to bury them. One hundred steam shovels were used to dig holes and 35 tractors pulled animals into place. Boy Scouts were organized to search for animals and bodies. As soon as they found one they placed a red flag beside it. A crew with picks and shovels followed and dug the animals' graves and buried them.

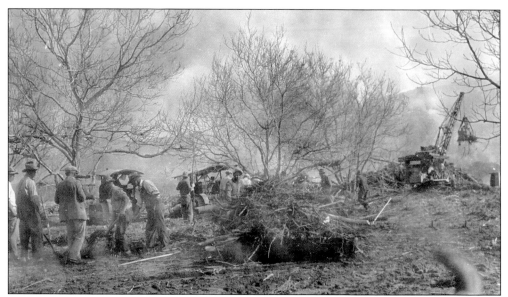

WORKERS CLEAN UP. Associated General Contractors put 3,000 men to work within 36 hours, removing 65,000 cubic yards of silt, which had all but buried fruit orchards and neighborhoods near the Santa Clara River.

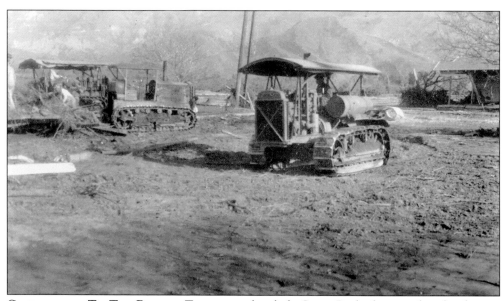

CATERPILLARS TO THE RESCUE. Tractors used to help Santa Paula dig out after the disaster were once used by the L.A. City Street Maintenance Department. Some had also been used to cut roads into Mines Field, now known as L.A. International Airport. The Caterpillar, one of the most powerful pieces of equipment in its time, was one of five tractors sent by the fledgling City Engineering Department.

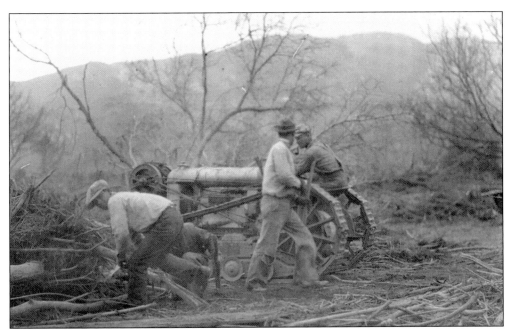

FROM EL RIO TO SANTA PAULA. Starting at El Rio at daybreak on March 17, 20 tractors and several hundred men worked their way toward Santa Paula. First came the tractors, pulling each brush pile and each pile of debris apart. Next came the "dead searchers" for human bodies, followed by Boy Scouts, hunting for animals. Behind them came the "burners."

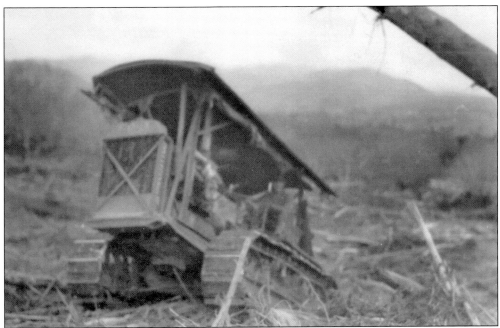

THE SILENT WORKERS. Harold Lemon drove a 1922 Holt tractor. He and coworkers lived in makeshift tents and were fed by the Red Cross. He particularly remembered the silence of the volunteer crews, many of them survivors who had lost family members, who worked beside his tractor. "Their faces were pale and lifeless and they worked just as if nobody was there with them."

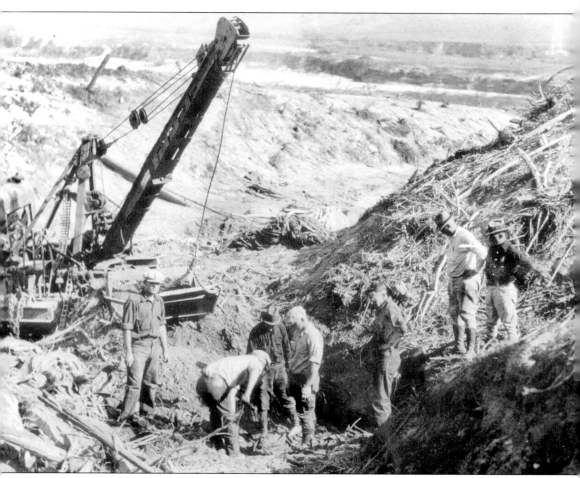

A SURPRISE FOUND IN A PILE OF DEBRIS. Some of the piles of debris were 30 to 40 feet high and couldn't be burned until they were taken apart, piece by piece, to see if any bodies were there. One gang of men working over a huge pile a mile west of Santa Paula uncovered a nest of over 50 rattlesnakes.

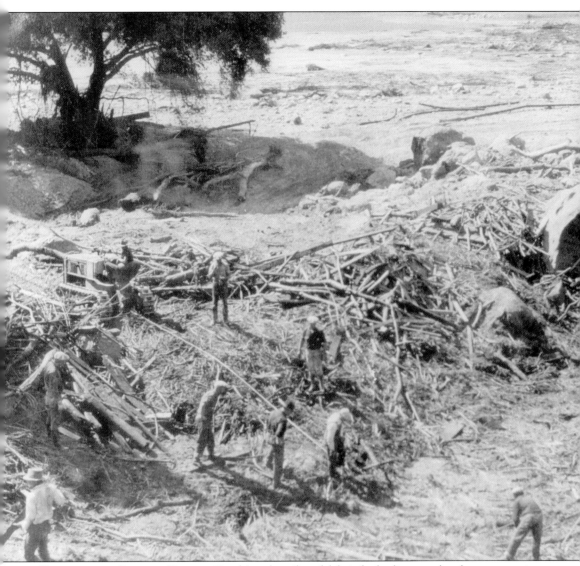

COMBING THE PILES OF DEBRIS. Combing the piles of debris for bodies was slow but systematic work. Steel cables used to tie on to the piles of brush to haul them apart were continually snapping under the strain. Chains would break and had to be brought to the blacksmith shops where they were welded again. Workers toiled amid the stench of the dead and were exposed to the acrid smoke of the burning debris. Water and food had to be provided. Police were stationed along the edge of the wreckage to keep looters out of the territory.

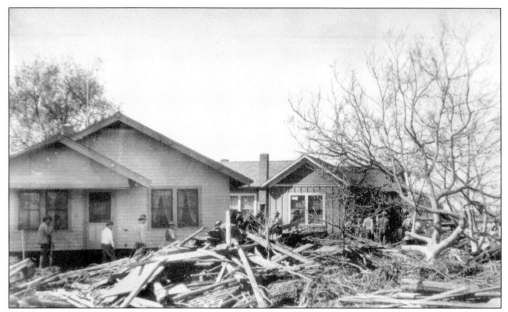

BLACKSMITHS FORGE ALL NIGHT. Using farming implements and improvised hooks, thousands of searchers slowly cut their way through the debris that clogged the valley floor in the face of treacherous quicksands and scourge. The blacksmiths at Fillmore worked far into the night, forging hooks to be used, while fellow townspeople were collecting all available horses, tractors, and equipment for rescue work and clean-up.

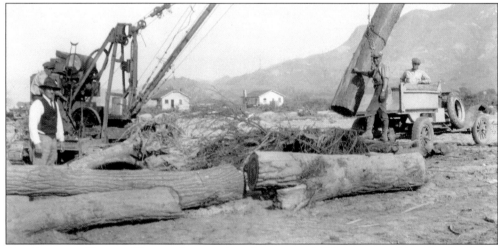

OIL COMPANY RESCUE TEAMS. At one time there were 4,000 men searching for the living and the dead. Much of the work was supervised by the American Legion with the aid of oil companies operating in the Ventura Avenue field. Five of the major companies offered the assistance of their workers, trucks, and equipment to meet the great emergency.

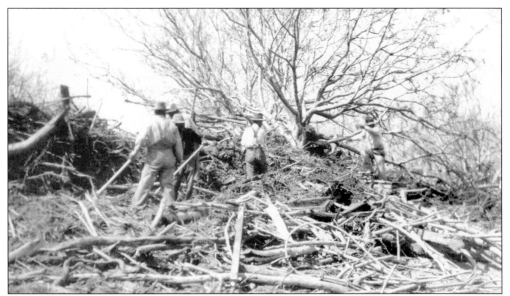

DEAD BODY RECOVERY. By sundown on Wednesday, March 14, 274 bodies had been recovered. Twenty-four hours later the total had risen to 296. A month later it stood at 404 and was still climbing. An average of one person died for every two homes destroyed. An exact total will never be known because many of the dead were undoubtedly migratory Mexican workers.

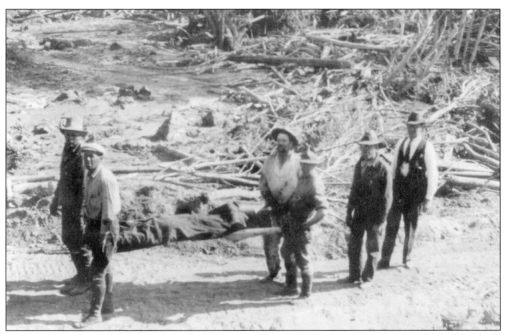

UNRECOGNIZABLE BODIES WERE BROUGHT IN. They were often so covered with mud and silt that they were unrecognizable. They were washed off with hoses and laid out and photographed for future identification. The bodies were embalmed and held as long as possible to be seen and identified. Undertakers came from San Luis Obispo, Santa Barbara, and Los Angeles Counties to help deal with the frightful harvest of death.

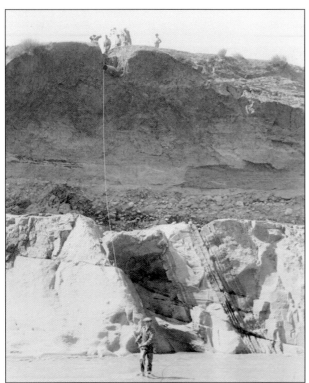

UTILITIES WERE RESTORED. The job of restoring gas pipelines ripped out by the flood was muddy, dirty, back-bending work but crews of Southern California Gas Co. worked night and day to restore the vital lines that brought gas from the northern producing fields into the valley and on to the Los Angeles basin.

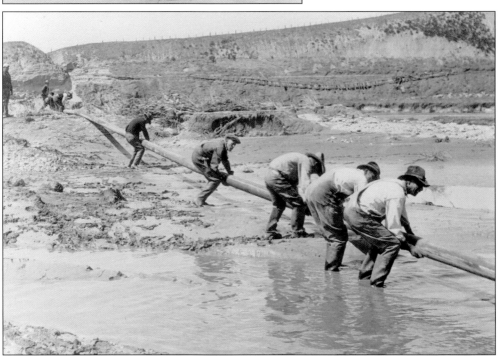

IT WAS A MUDDY JOB. Stringing a length of pipe across the flood-ravaged Santa Clara River bed was literally what the term implied. Pipe was put on a length of rope and "strung" across, with a man in hip boots guiding it across the muddy waters.

Six

REBUILDING AND RENEWING

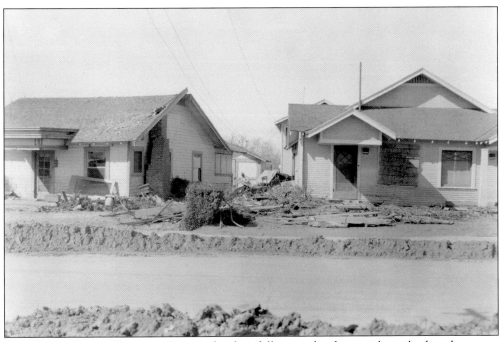

THE COMMUNITIES REBUILD. During the days following the disaster the only thought was to save human lives and recover the bodies of those who were caught in the swirl of the flood. The problem of rehabilitation was then given attention. The Los Angeles City Council appointed a Committee of fourteen to cooperate with a like Committee of Ventura County and take complete charge of the restoration work.

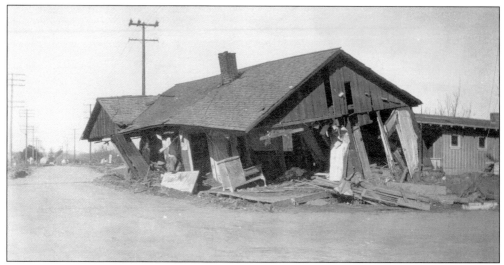

A Telegram to a Plumber. John Uffen, a Santa Paula plumber, received the following telegram: "The fateful disaster that has fallen to your city has stirred our deepest sympathies, trust you will advise just what conditions are, insofar as trade itself is concerned we stand ready to do our share in extending financial aid to members of our profession in distress." *The Plumbers and Heating Contractors Trade Journal.*

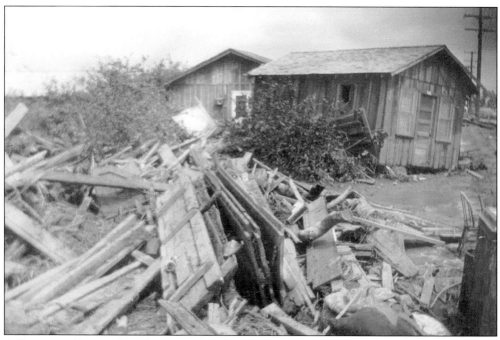

A Scene on South Oak Street. Three hundred Santa Paula homes in the southern section of town were swept into a mass of wrecked and tangled timbers.

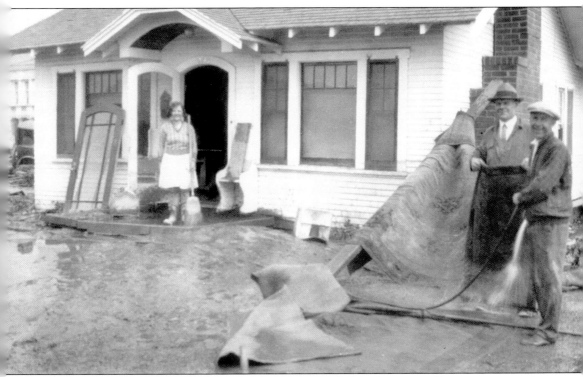

A Reasonable Apprehension That It Is Liable. An Authorization Form was prepared with the plans for the restoration of each damaged or destroyed building. It read in part: "The undersigned owner having presented a claim to the City of Los Angeles for loss and damage to buildings and fixtures occasioned by flood waters released through the destruction of the St. Francis Dam, belonging to the city of Los Angeles, on March 13, 1928, and the said City having a reasonable apprehension that it is liable for damages by reason thereof, the said City proposes, and the undersigned hereby accepts, the following as the plan and method agreed upon for the settlement and release of said claim for damage to buildings, structures and fixtures."

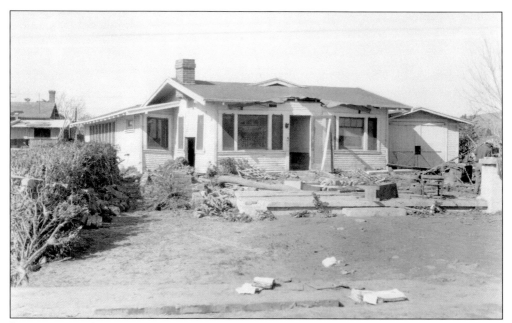

INFORMATION ON EACH BUILDING WAS CAREFULLY GATHERED. It was necessary to gather information carefully regarding the type of construction and the quality and character of the finish of each of the damaged or destroyed buildings. This was obtained after systematic critical inspection of the properties by qualified expert investigators.

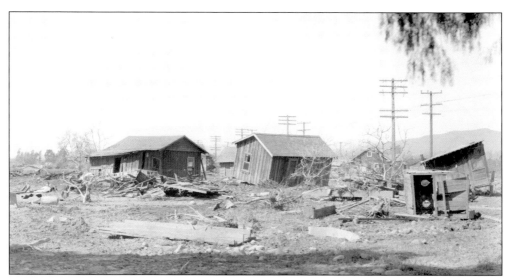

INFORMATION CAME FROM VARIOUS SOURCES. Information regarding the destroyed buildings, their construction, and quality of appointments and finish was obtained from various sources such as the contractors who built them originally, mortgagors, the original owners, and other individuals familiar with the buildings prior to the disaster.

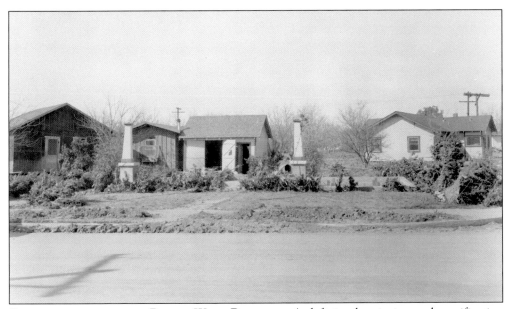

SPECIFICATIONS FOR THE REPAIR WERE PREPARED. A definite description and specification for the repair to the damaged building was prepared and attached to an Authorization granting permission to enter the property and to perform the specified work.

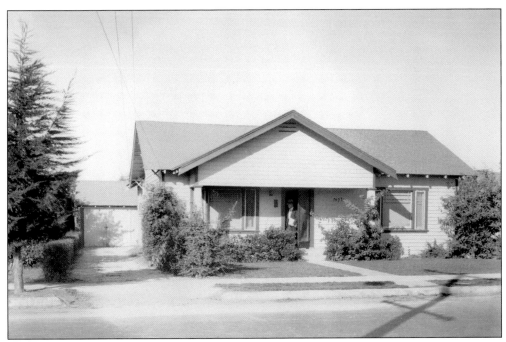

A RESTORED HOUSE AND GARAGE. In many cases the homes were rebuilt better than they were before the disaster. The top photo shows the property before restoration.

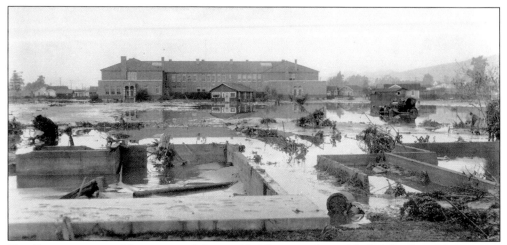

THE SCHOOL ON THE MORNING OF MARCH 13. This view shows Isbell School on 7th Street in Santa Paula with the family home of Tom Riley that floated onto its grounds during the night. The school is in current use today. It was named after Olive Mann Isbell, the first American schoolteacher in California, holding her first class in 1846. She eventually settled in Ojai and Santa Paula.

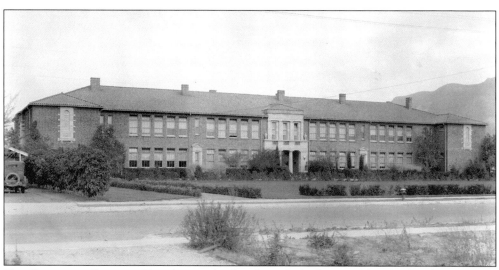

THE RESTORED SCHOOL. Two thousand cubic feet of silt deposited by the floodwaters were removed from the first floor.

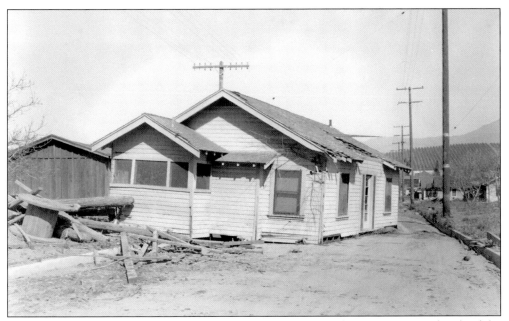

PLANS ARE MADE. "Salvage Plans" were prepared giving complete construction details of the entirely destroyed buildings, the plans being evolved from information compiled in the field by special investigators.

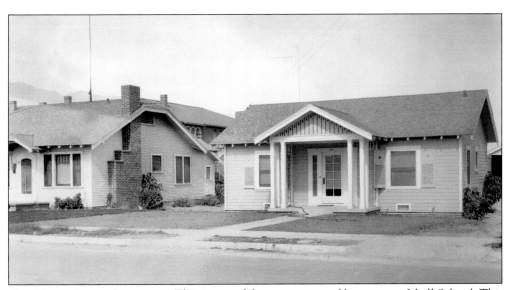

THE HOME ABOVE RESTORED. This is one of the many restored homes near Isbell School. This photograph and many others were taken by the town photographer and carries the blind stamp "Clearwater Santa Paula."

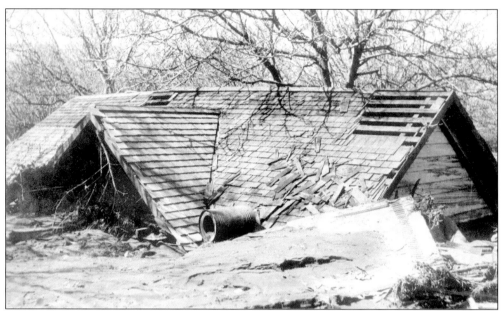

A Roof Caught By Trees. The destruction here includes dwelling and cesspool, double garage, chicken house and corral, rabbit hutch, dog pen, and fences.

This Property Is Condemned. This structure did not comply with the State Housing Act in many ways. An attempt to recondition it and comply with the Act would have required considerable expense and additional work. A "salvage house" belonging to the City of Los Angeles by virtue of having made full restoration was moved onto the premises and put into livable condition.

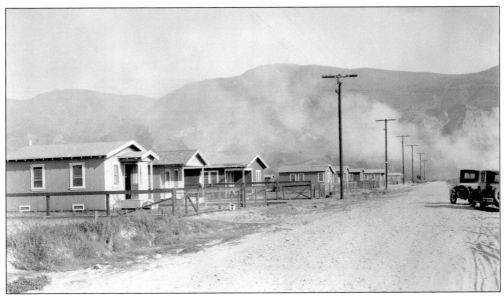

BARKLA STREET, SANTA PAULA, RESTORED. All buildings and fences on this street were washed away leaving no evidence of their previous condition. It was named for John Samuel Barkla who was born in England and came to California in 1853 as a miner near Placerville. He arrived in Santa Paula in 1871.

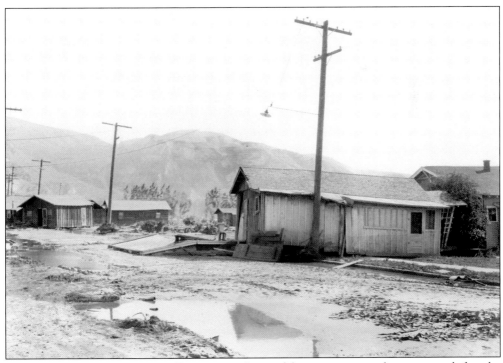

A CAREFUL ESTIMATE WAS PREPARED. A careful estimate was then prepared for the construction of a new building to replace the one destroyed and the owner had the option of accepting this value in cash or its equivalent in new construction.

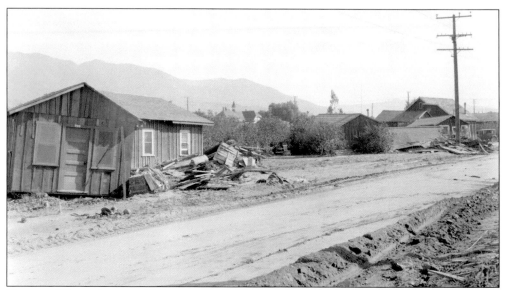

CHOICES WERE OFFERED. If the owner preferred restoration by way of new construction then plans and specifications were prepared which represented value equivalent to his loss.

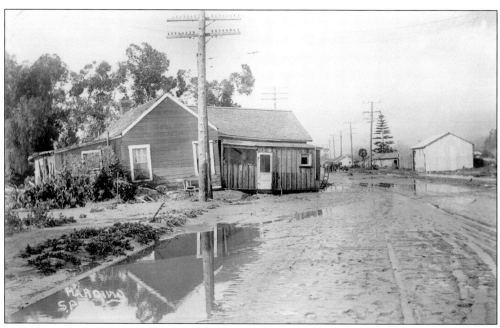

BETTERMENT WAS OFTEN PREFERRED. In some cases the owner preferred betterment to the estimated value of his destroyed building and plans and specifications were prepared according to his wishes. The owner paid the difference between the enhanced construction and the value of the destroyed building.

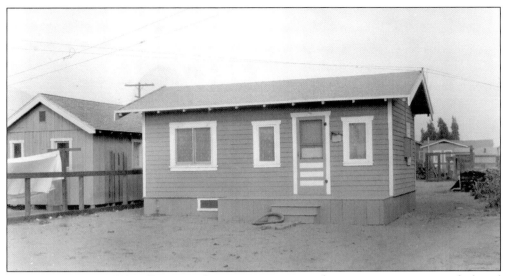

NOT EVERYTHING WAS REBUILT. In certain instances the owner, on account of altered conditions, had no further use for a full building restoration. In such cases plans and specifications were prepared for only as much building as the owner desired. The difference between that cost and the value of the destroyed building was paid in cash.

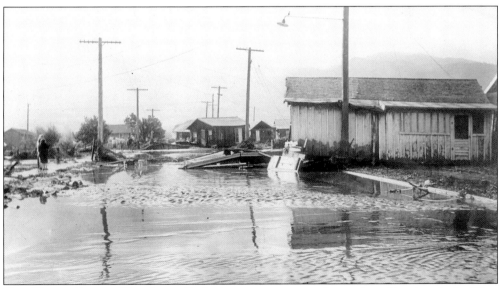

OLD HOMES FOUND NEW LOTS. Each claimant was given the option of having the building restored on other land than that upon which it originally stood.

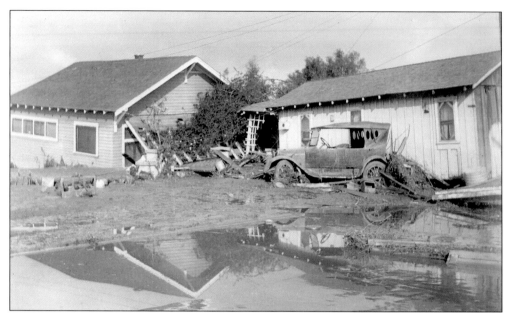

CONSOLIDATION WAS AN OPTION. Some claimants suffered complete loss on two or three parcels of land and requested that the restoration be made by combining their total losses into an equivalent building restoration in another location.

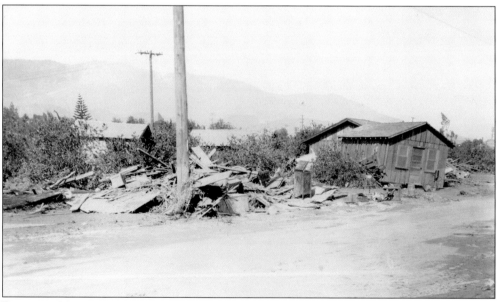

BUILDING MATERIALS WERE RECYCLED. In some instances portions of buildings that were torn apart and badly damaged were used to restore the buildings of other claimants. This was found to be not only economical for the City of Los Angeles but also profitable to the claimant as well.

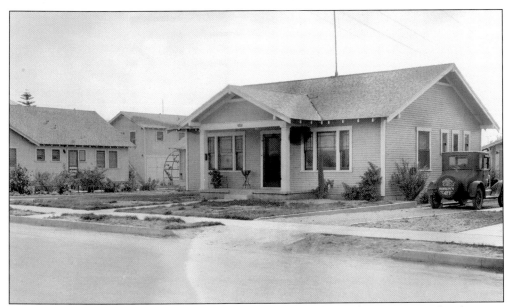

A Restored House, Garage, and Chicken House. With very few exceptions the claimants preferred to have restoration effected by actual building rather than cash, particularly after it had been demonstrated that the restoration was expertly done.

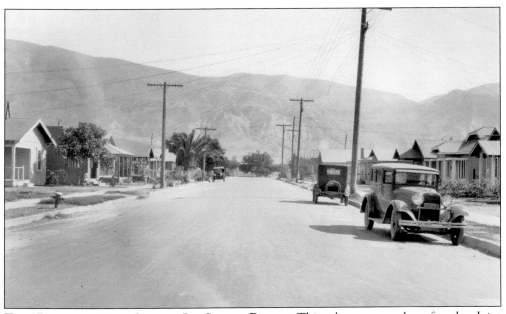

The Restored 7th Street In Santa Paula. This photo was taken for the Joint Architectural Committee report. The Sub-Committee on Death and Disability Claims was also compensating victims but a lost life was more difficult to measure than a lost building. In one case they gave Nora McDougal $15,000 as settlement for the death of one adult while Emilio Quezada received $500 for the death of one adult.

THE RESTORED EAST HARVARD STREET. Beyond these homes to the east was Ralph Dickenson's ranch with three airplane hangars where he and several ranchers had kept their planes and flew. After the flood Dickenson and another rancher, Dan Emmet, decided to buy the property along the river that had been stripped bare by the flood and build a 1,500-foot airstrip. Today's Santa Paula Airport is the result of their farsightedness.

ANY TRACE OF THE DISASTER IS NOW DIFFICULT TO FIND. As in most great disasters, it was possible to restore buildings in such a way as to leave the community in better physical condition than it enjoyed prior to the unwelcome event.

128